PHOTOGRAPHS BY HIROSHI SUGIMOTO

TEXT BY JONATHAN SAFRAN FOER

JOE

DESIGNED BY TAKAAKI MATSUMOTO

PUBLISHED BY THE PULITZER FOUNDATION FOR THE ARTS

PRESTEL

PREFACE

In July of 2003, Hiroshi Sugimoto visited the Pulitzer Foundation for the Arts in St. Louis. Eckhard Schneider, director of the Kunsthaus Bregenz (Austria), had arranged for him to come.

Initially, Sugimoto intended to take photographs of the Pulitzer building, which was designed by his fellow countryman Tadao Ando. However, he quickly focused on Richard Serra's *Joe*, a sculpture which was commissioned as part of the Pulitzer Foundation for the Arts. The first of Serra's torqued spirals, *Joe* is installed in the courtyard.

Like a work of architecture, this sculpture has to be experienced by walking around and through it. The only torqued spiral that is permanently installed outdoors, *Joe* is different according to the time of the day, the season, and the viewer's position. It is in the visitor's memory that the sculpture "takes shape" in the most complete way.

Sugimoto's photographs of *Joe* and the sculpture itself are quintessentially parallel creations. Using a photographic technique involving areas of extremely soft light and blurred darkness, he sculpted views that seem like aspects of visual memory: the arts of photography and sculpture overlap and memories of the two- and the three-dimensional mix.

To further the idea of parallel creations, Sugimoto suggested for this book commissioning a text by a novelist. Jonathan Safran Foer's deep interest in the juxtaposition of the visual arts and poetic language predestined him to be part of the project. He composed a text in relation to the sculpture and the photographs without describing or defining them.

Takaaki Matsumoto designed the book. He created the "place" for the appreciation of Sugimoto's and Foer's parallel creations. In the same way, the Pulitzer Foundation for the Arts is a place for creation and inspires a very personal experience.

The title of the book is *Joe*. The protagonist of Foer's text is *Joe*. The title of the sculpture in the courtyard of the Pulitzer is *Joe*. Those who knew the late Joseph Pulitzer, Jr. may perceive *Joe* as a very personal homage. Those who are unaware of that connection simply perceive the name as an unassuming title for a specific work of art. *Joe* "belongs" to those who are inspired by it.

From May 12th until October 14th, 2006, The Pulitzer Foundation for the Arts presents nineteen of Sugimoto's photographs. This body of work is installed in relation to the contemplative aspect of the galleries and to *Joe* in the courtyard.

Matthias Waschek

Director

The Pulitzer Foundation for the Arts

JOE

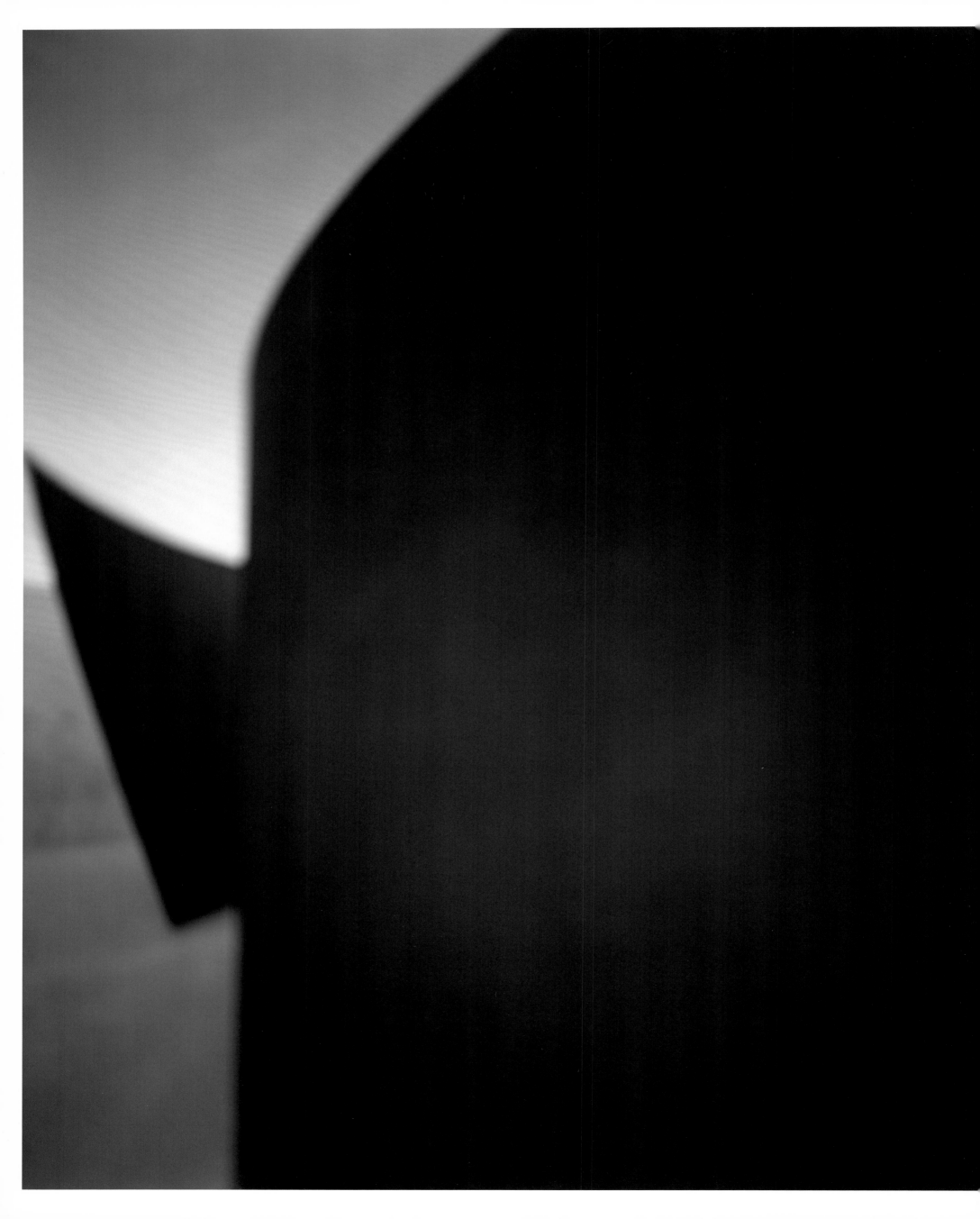

With a fishing line,

Joe sews shut the pockets of his jacket.

It's his favorite jacket,

because it has so many pockets—

four on each side of the chest.

Joe's wife comes in from the garden
and asks what he's doing.

He says, "I realized there's no need
to carry anything anymore."

There's dirt under her red fingernails.

In her purse, in the closet,
is a little blue book filled with ideas.

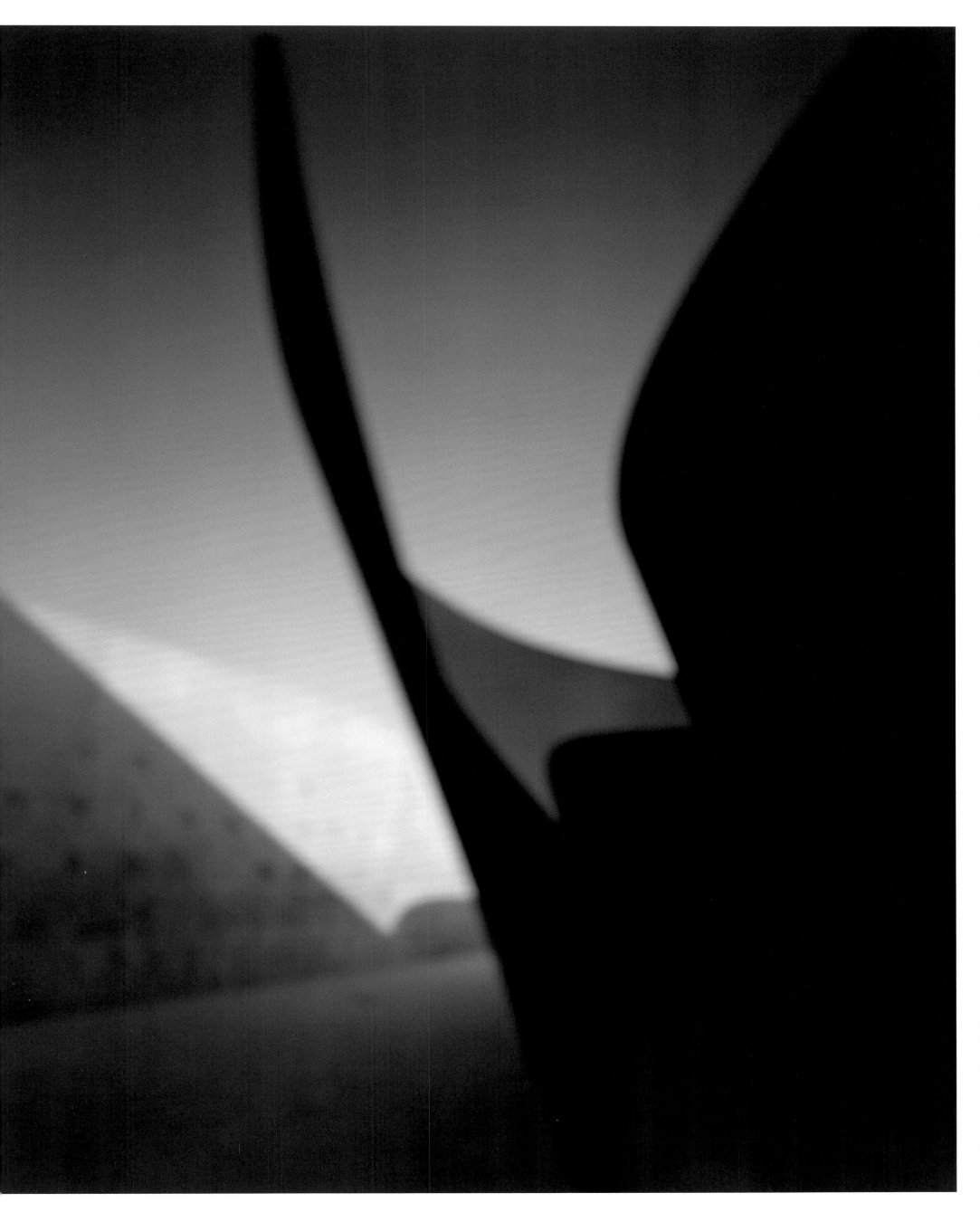

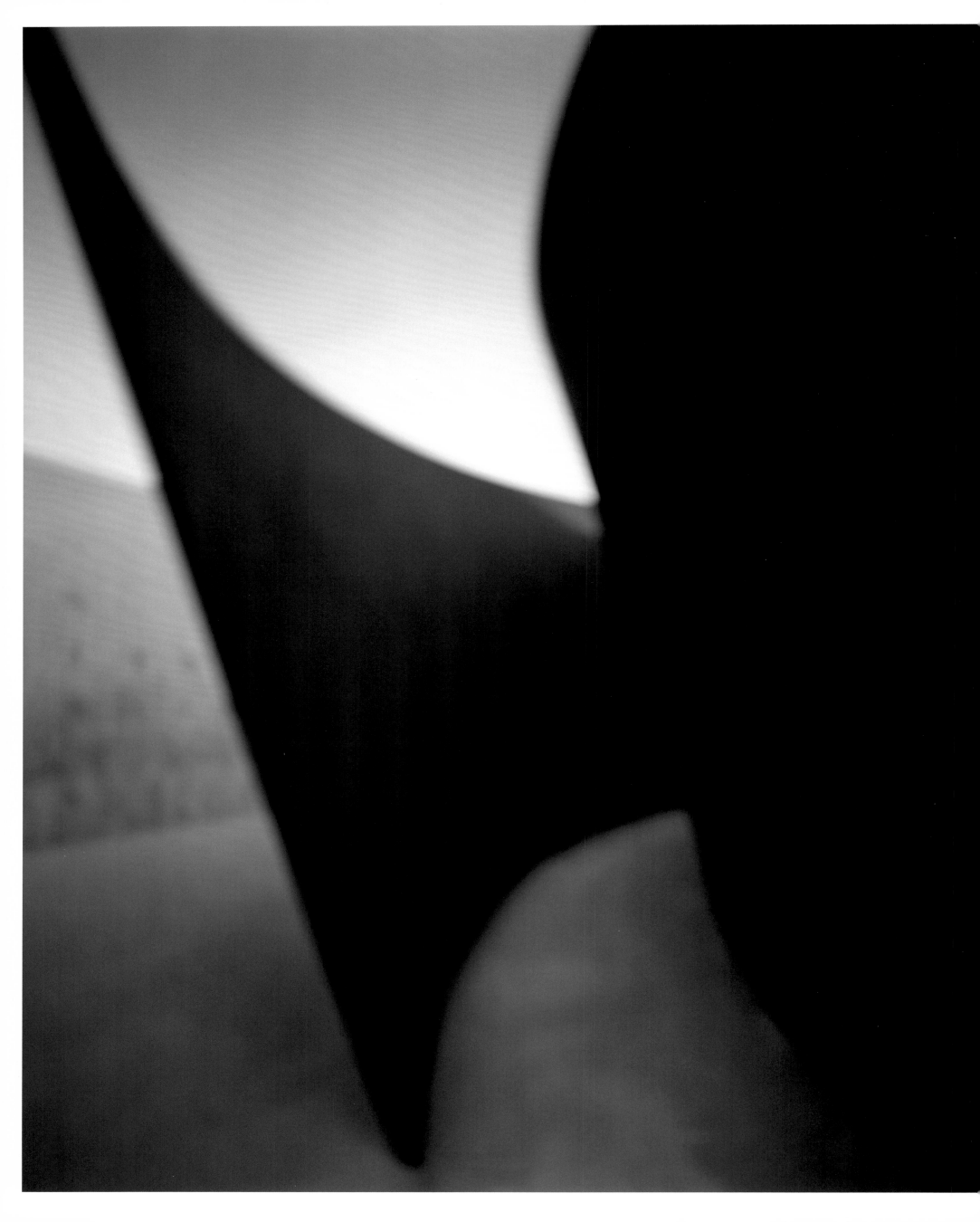

She wipes her brow with her forearm and says,

"I wish you wouldn't do that."

He makes another stitch and says,

"I'm not going to start believing in things.

That's not who I am."

She goes back out to the garden

to finish the planting

and calls through the window,

"But what if it's who I am?"

Joe hasn't fished since his daughter was born.

Joe went for a walk around the hospital,

the morning his daughter was born.

He saw a dog without an owner.

It was no more than twenty feet ahead of him.

He called to the dog,

but it wouldn't come.

He took a step in the dog's direction.

The dog took a step away from him.

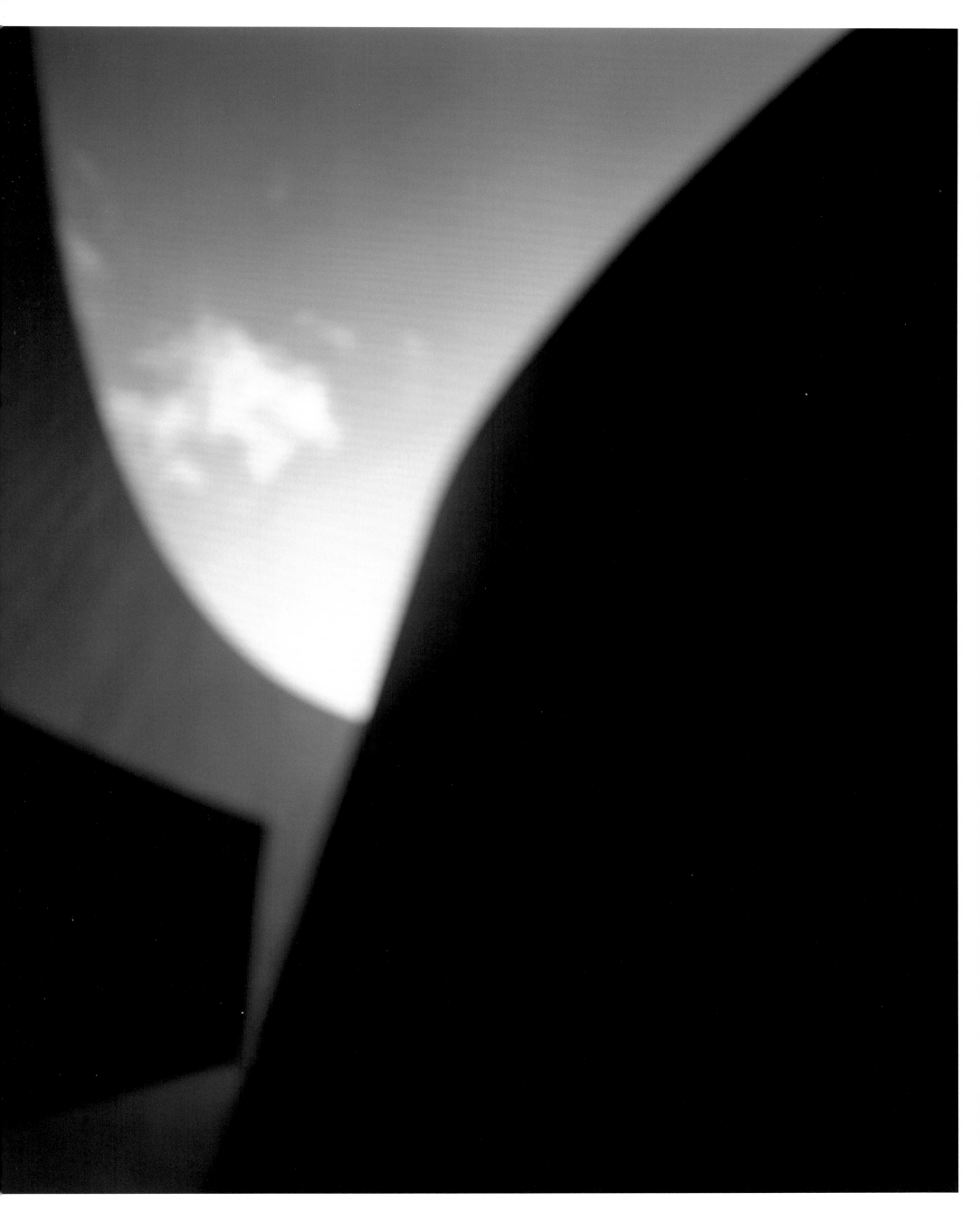

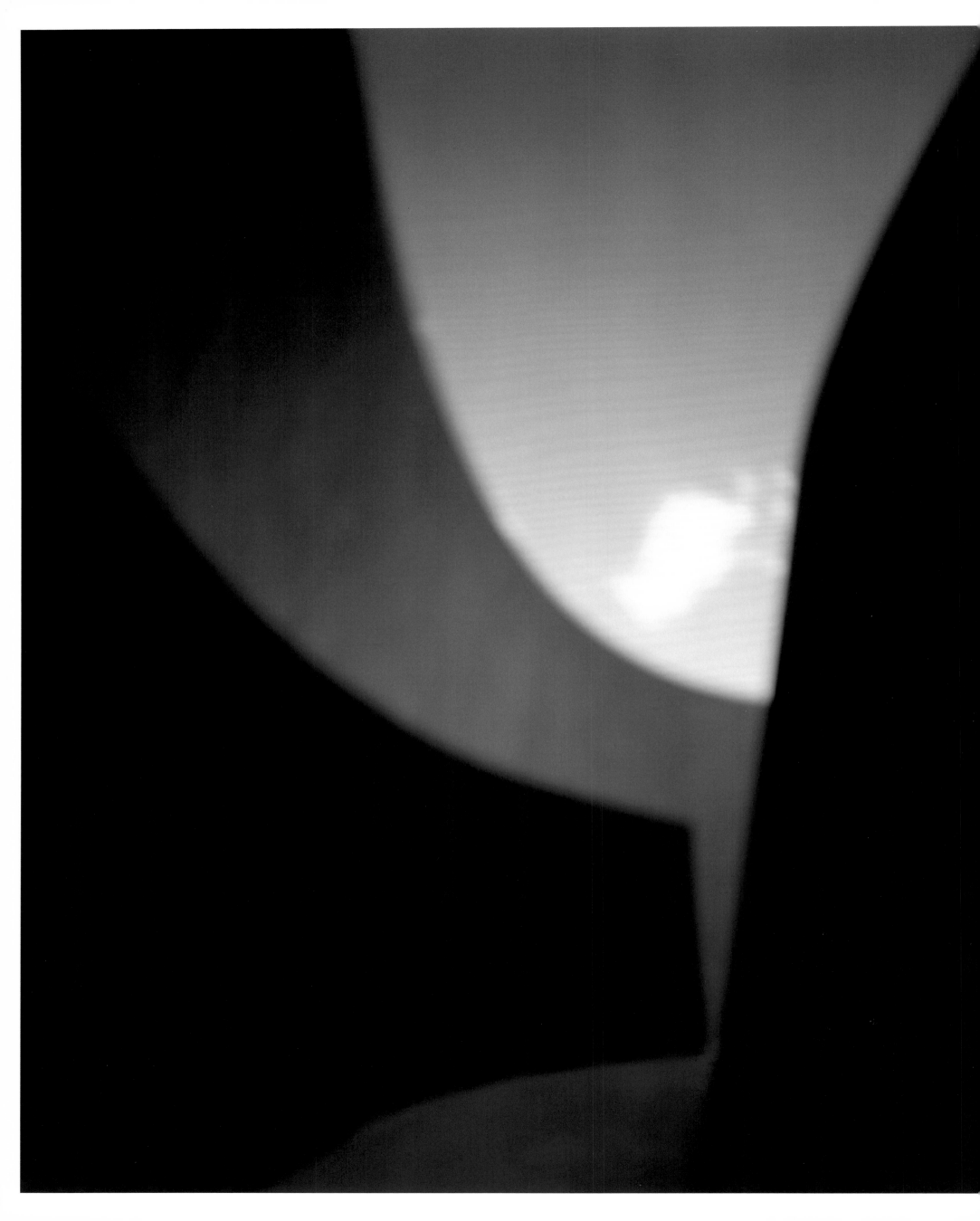

Joe said, "I'm not going to hurt you,"

and walked faster.

The dog walked faster.

Joe called ahead to people on the sidewalk,

but by the time they understood what he was saying,

the dog was already past them.

Or maybe they thought Joe was crazy.

The dog veered into the street.

Joe ran.

The dog ran.

A few hours earlier,

Joe had stood at the window

of the maternity ward.

The only sound was the ticking

of his pocket watch.

Joe put his palms against the glass

and thought he could feel

the vibrations of the heartbeats.

Is a promise a promise

if you know you won't be able to keep it?

Into the watch's back was engraved

Joe's grandfather's name.

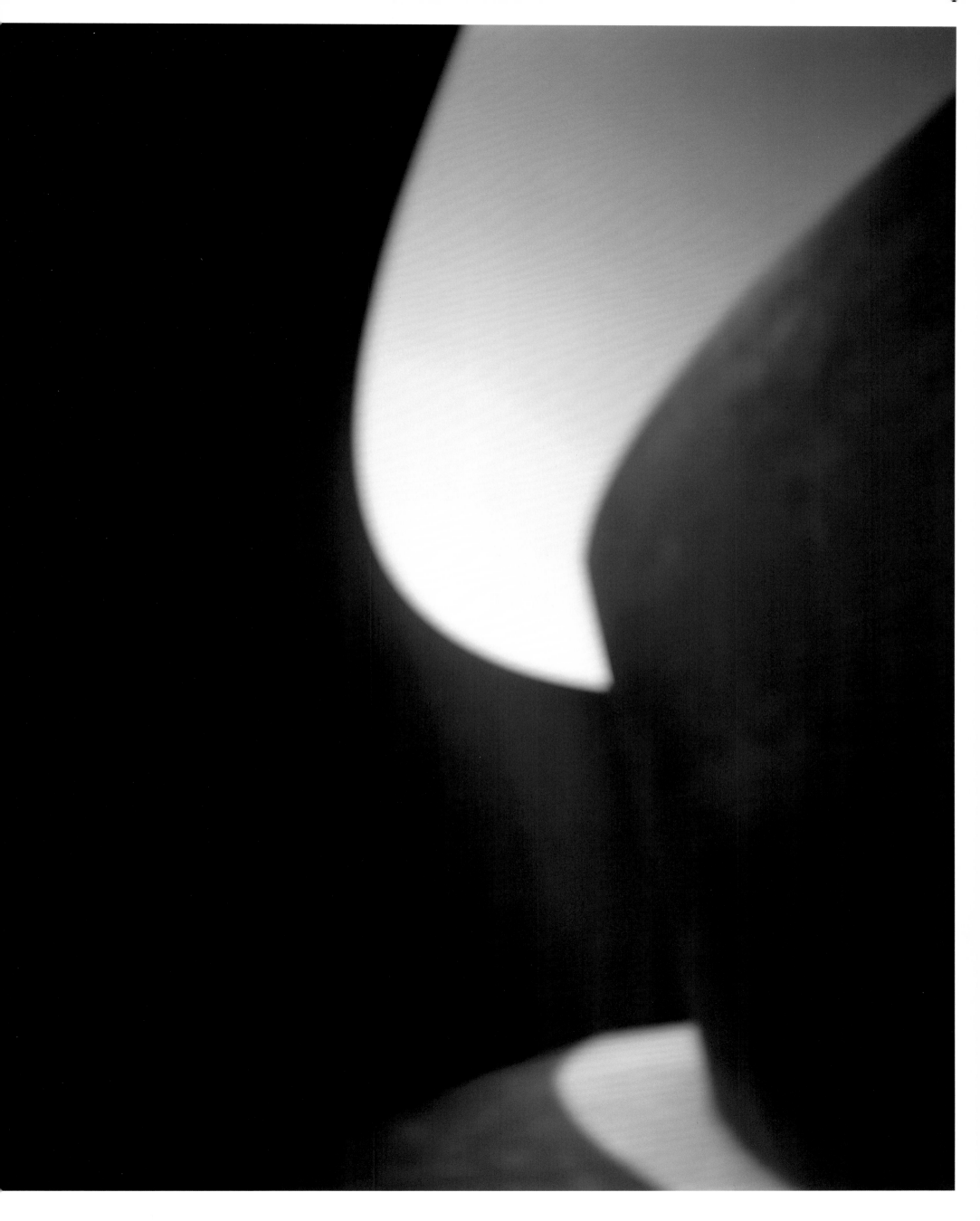

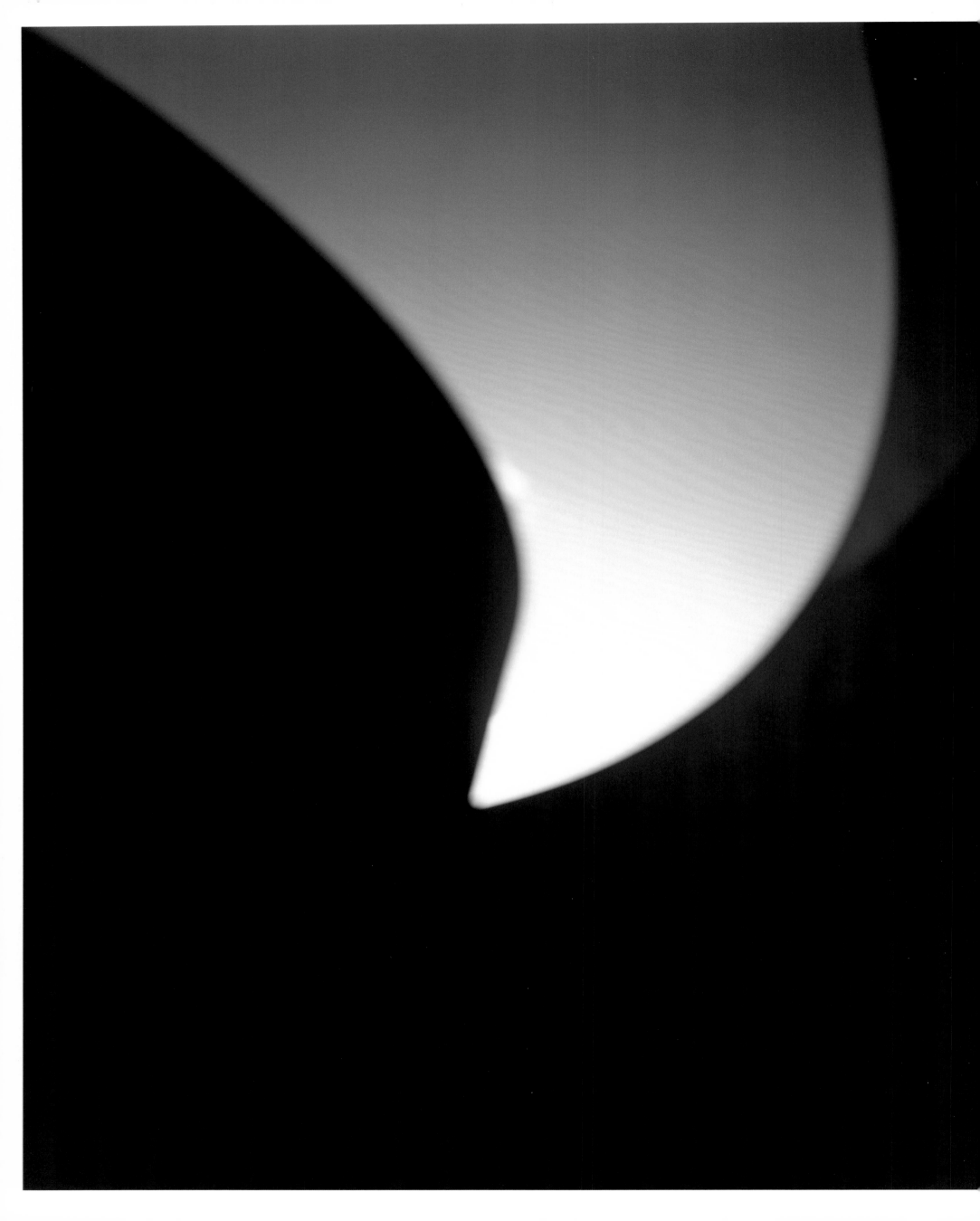

From then on,

Joe always carried a dog biscuit with him

wherever he went.

He never told anyone about it,

not even his wife or daughter.

And he never had occasion to use it.

But it served its purpose.

He is sewing the biscuit into the jacket.

The dog's owner was mute.

Because the dog never heard "come," "heel" or "stay,"

it never learned to come, heel or stay.

Which is why Joe wasn't able to lure it to him.

Which is why it disappeared to its unknown fate.

It never heard "good" or "bad,"

so it was never good or bad.

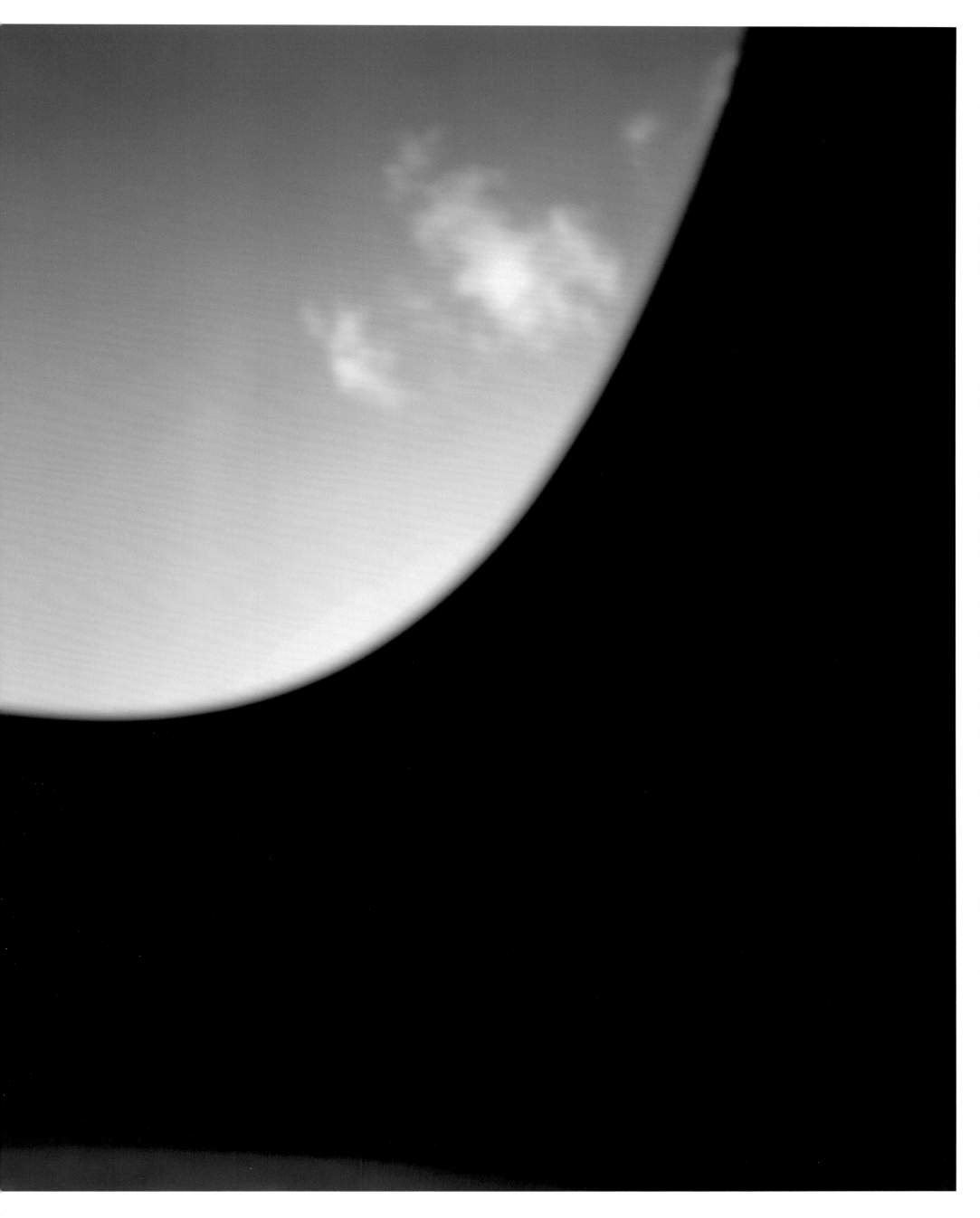

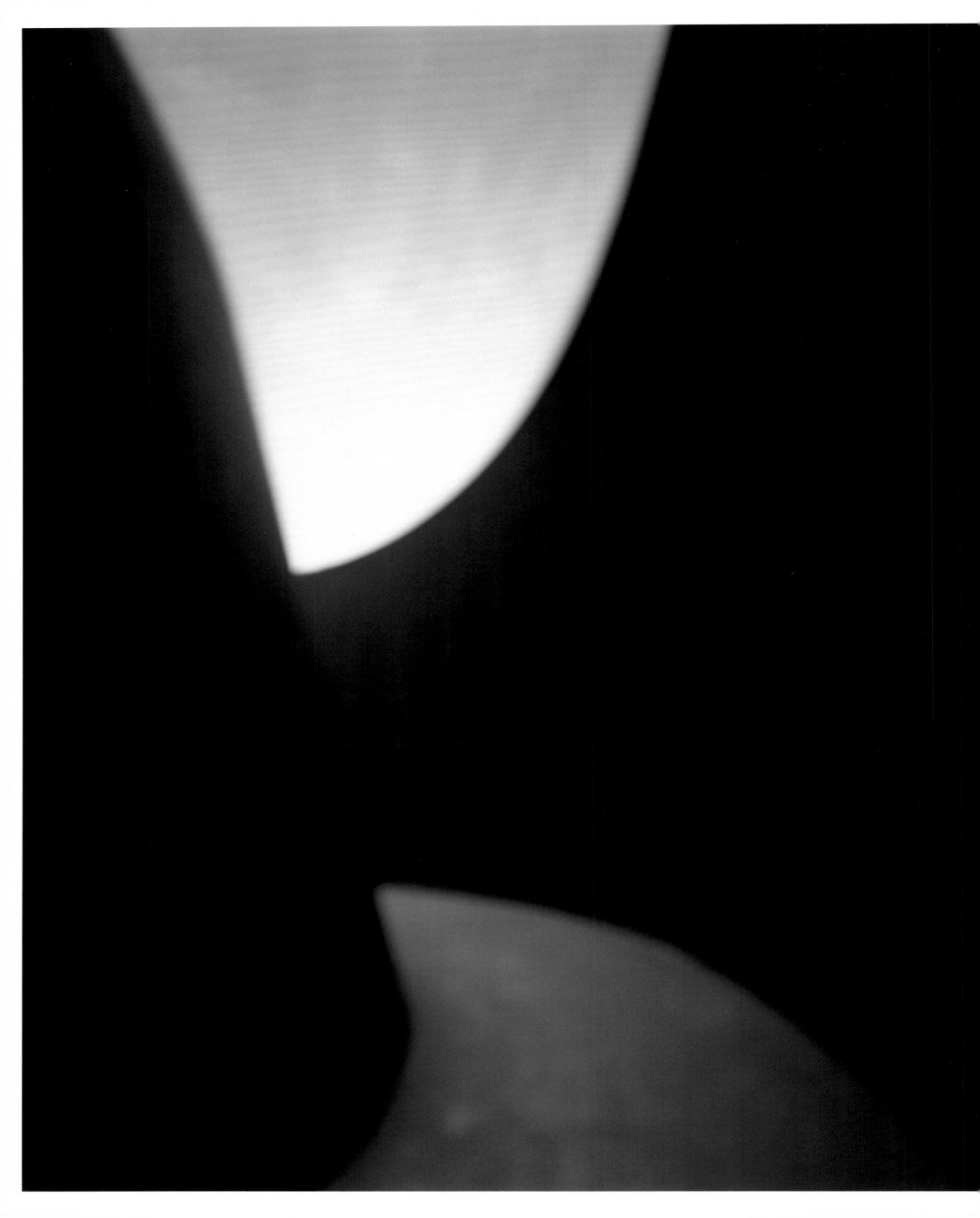

It never heard its name, so it didn't have a name.

Although in the owner's mind it had a name.

His mind was filled with things that only he knew.

It was the same for the dog.

There is a world without sound.

No one speaks, no one laughs out loud or wails.

Fires don't cackle.

Houses don't moan.

Waves crash, but silently.

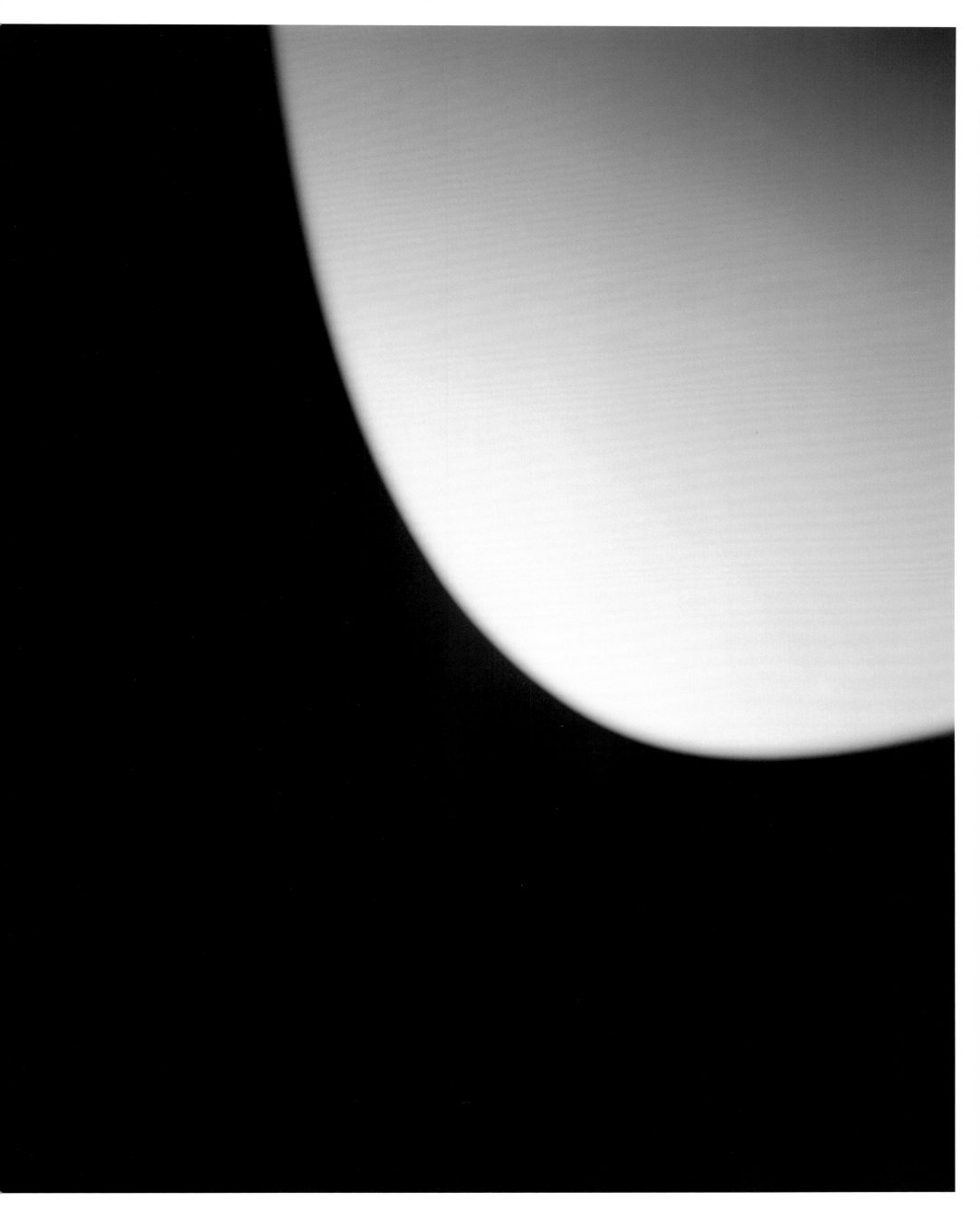

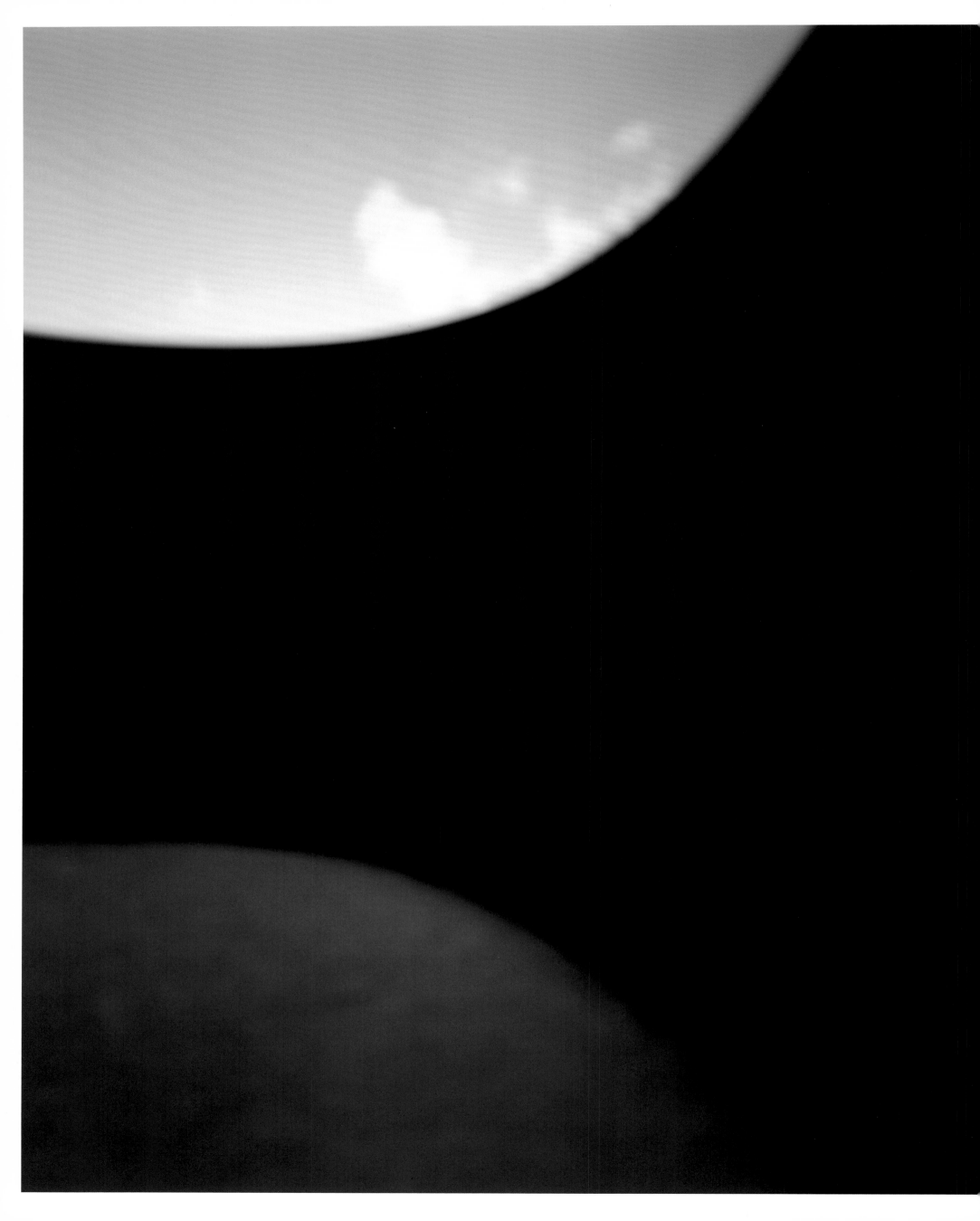

People still go to the symphony in large numbers,

but only to watch the bows run across the strings.

In the winter, concerts are held outside,

so the audience can see the breath

emanating from the ends of the wind instruments.

After the last silent note,

the conductor turns and bows,

and the crowd gives a silent standing ovation,

as if their hands were coming infinitely close—

over and over and over

—without meeting.

And then it starts to rain.

Miles from the applause,

a middle-aged woman

is in a house with no windows.

The rain on the roof makes no sound.

And when the electricity goes out,

she can't know if she is alone

in the dark house.

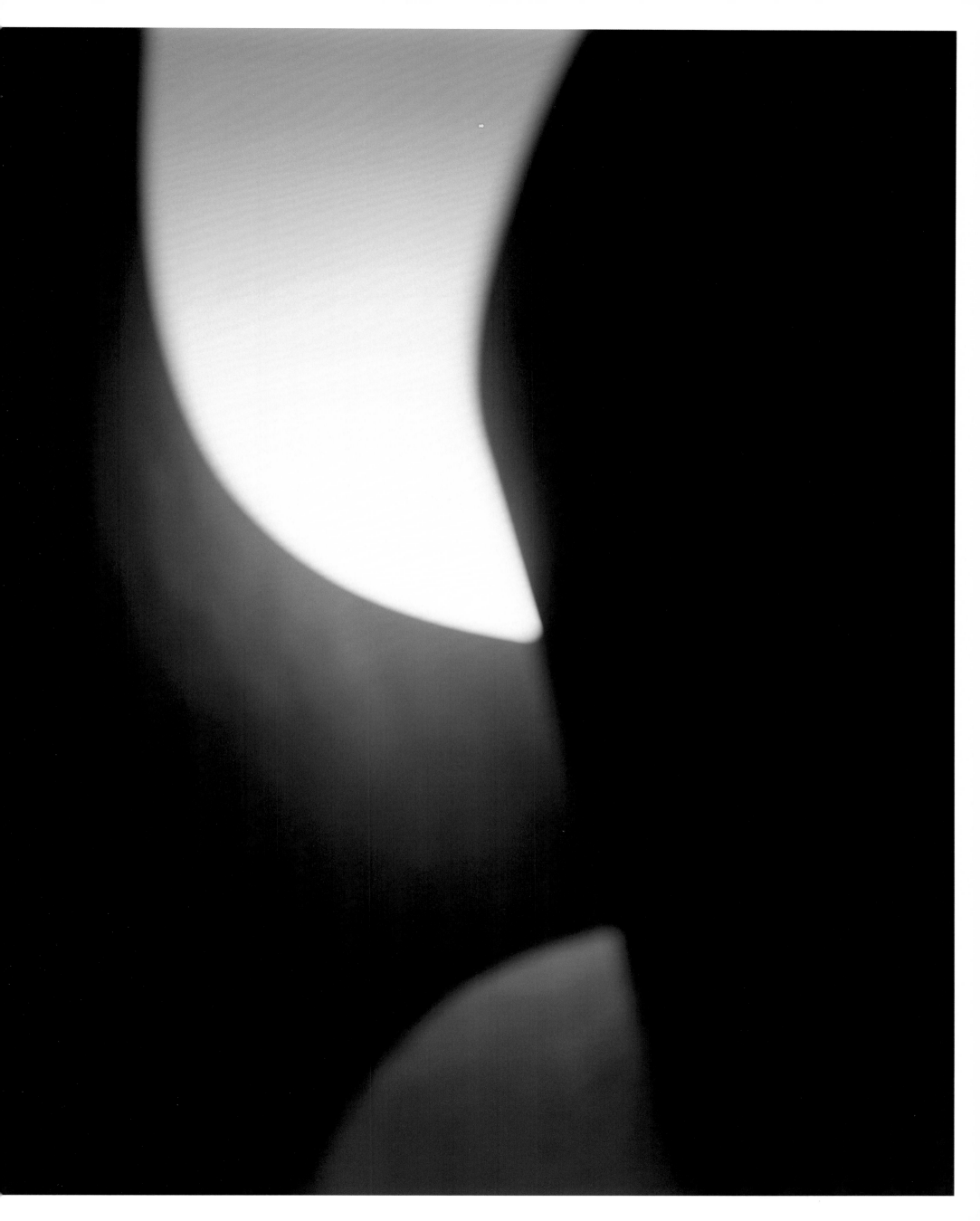

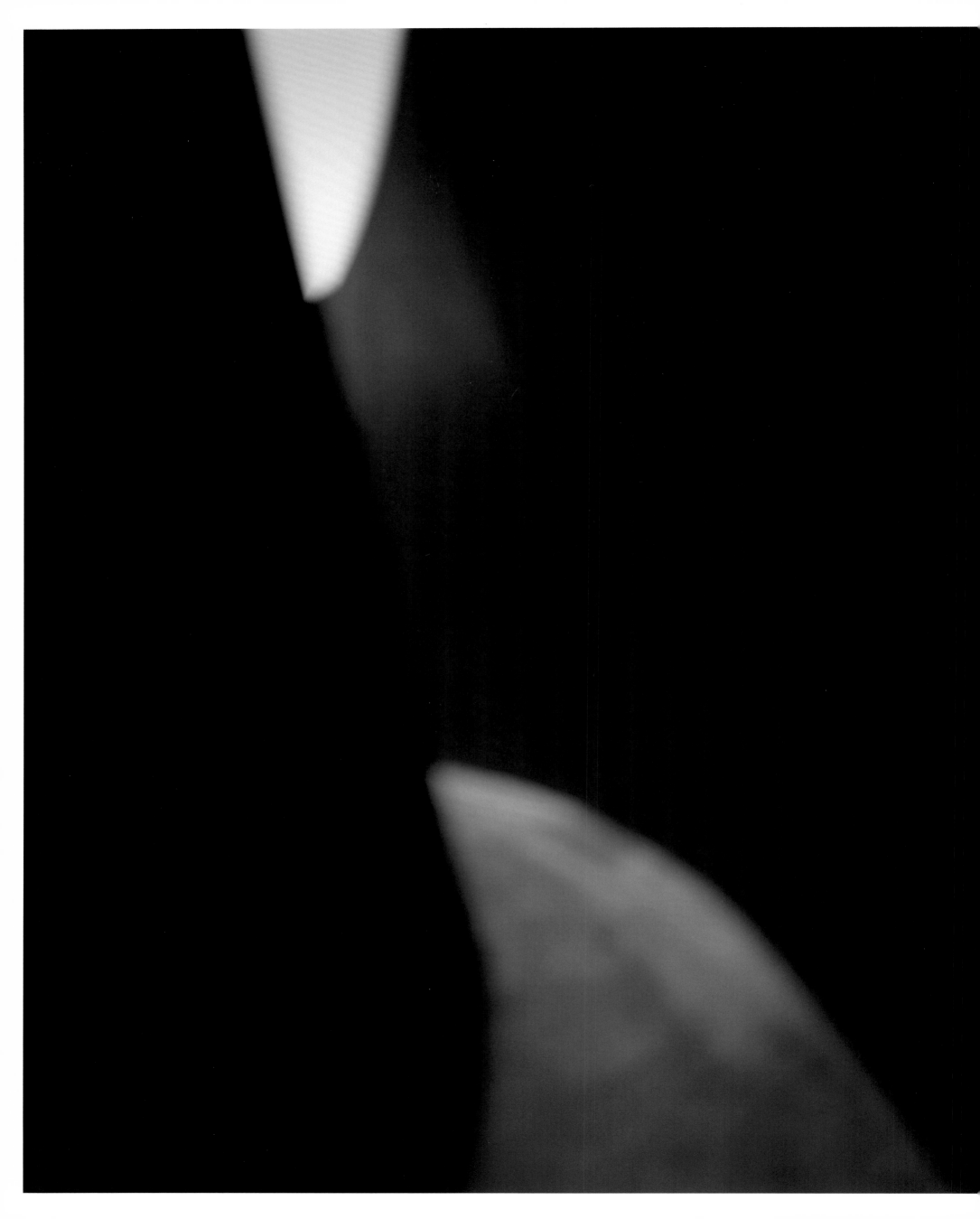

One afternoon, well into Joe's illness,

his wife was washing her face when she had

what she thought might be an important idea.

It came as a tremendous relief.

But as soon as the fingertips of her brain touched it,

the idea started to move away from her.

She put the soap in its tray and looked in the mirror.

If it's true that nothing can disappear,

that everything becomes something else,

what do lost ideas become?

She submerged her hands in the sink,

and the water felt ever so slightly warmer.

Had the idea warmed the water?

She thought about Joe's body.

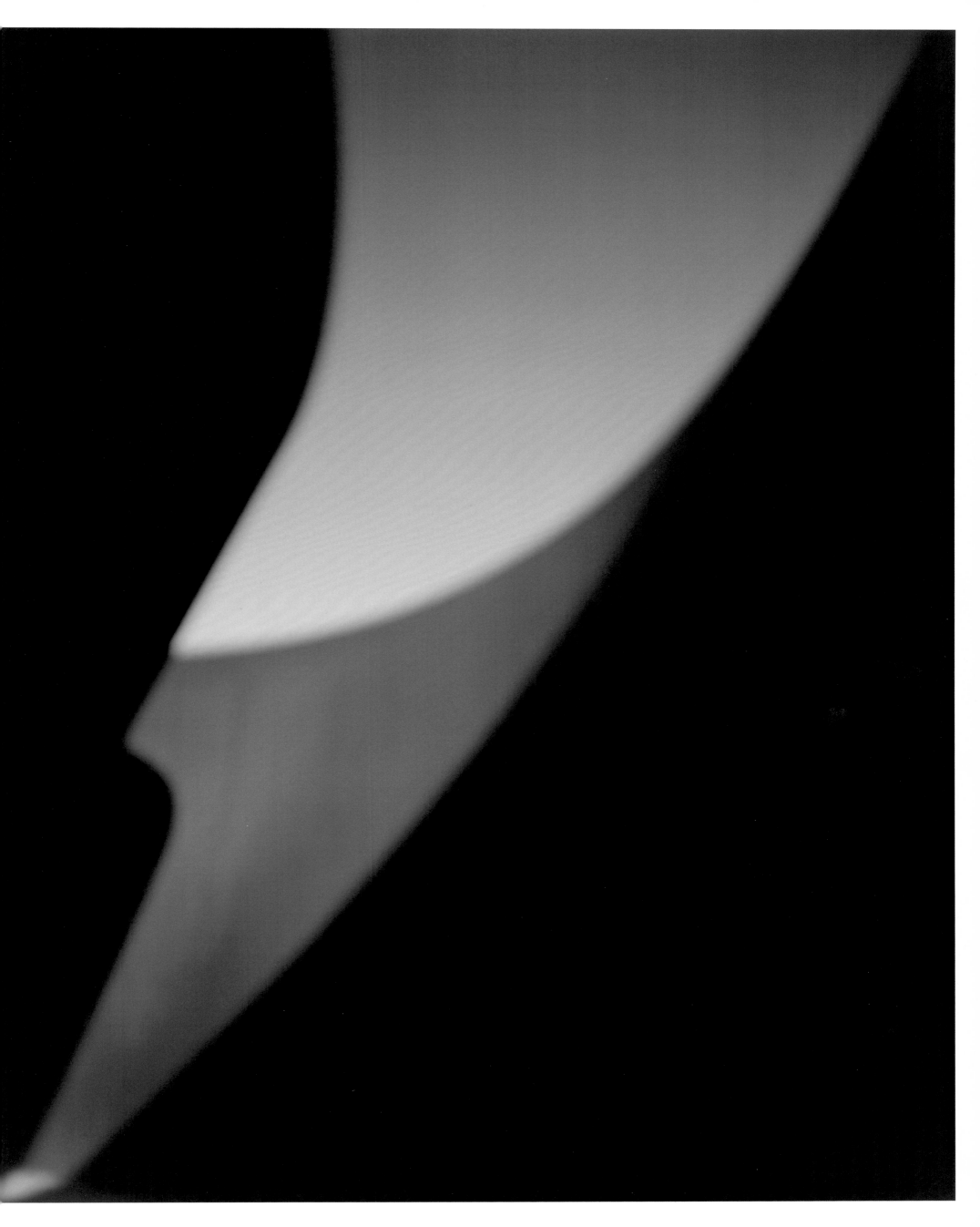

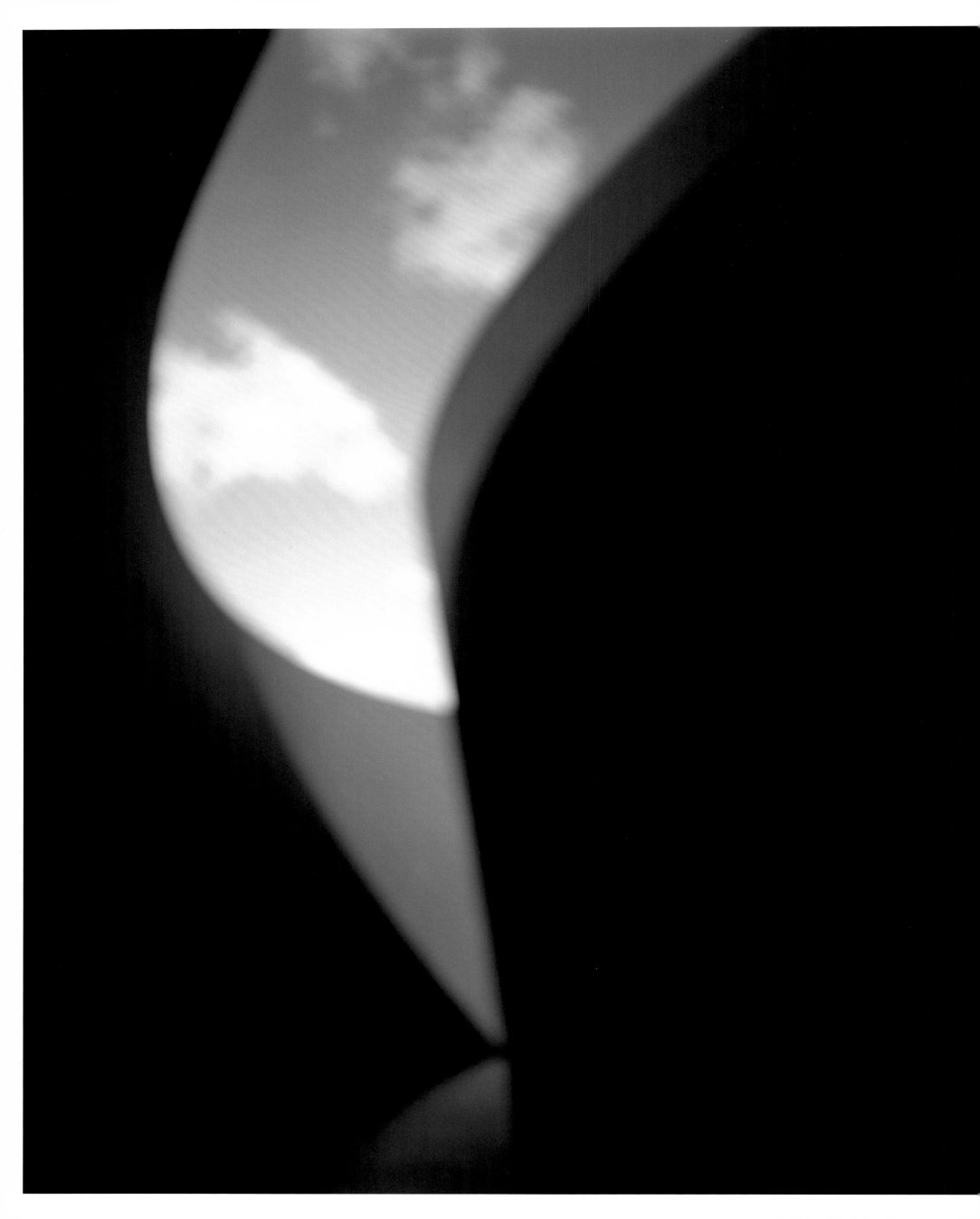

She thought about an article she had recently read

about architect-historians who rebuild

lost structures from the remnants

of their foundations—

houses in Pompeii,

shrines in Nagasaki,

synagogues in Poland.

But what if the foundations are deceptive?

She thought about the last time

they went to the beach as a family.

It was snowing.

They walked through the vapor of their breathing,

and left long trails of footprints.

Why didn't anyone say anything all afternoon?

There was so much to talk about.

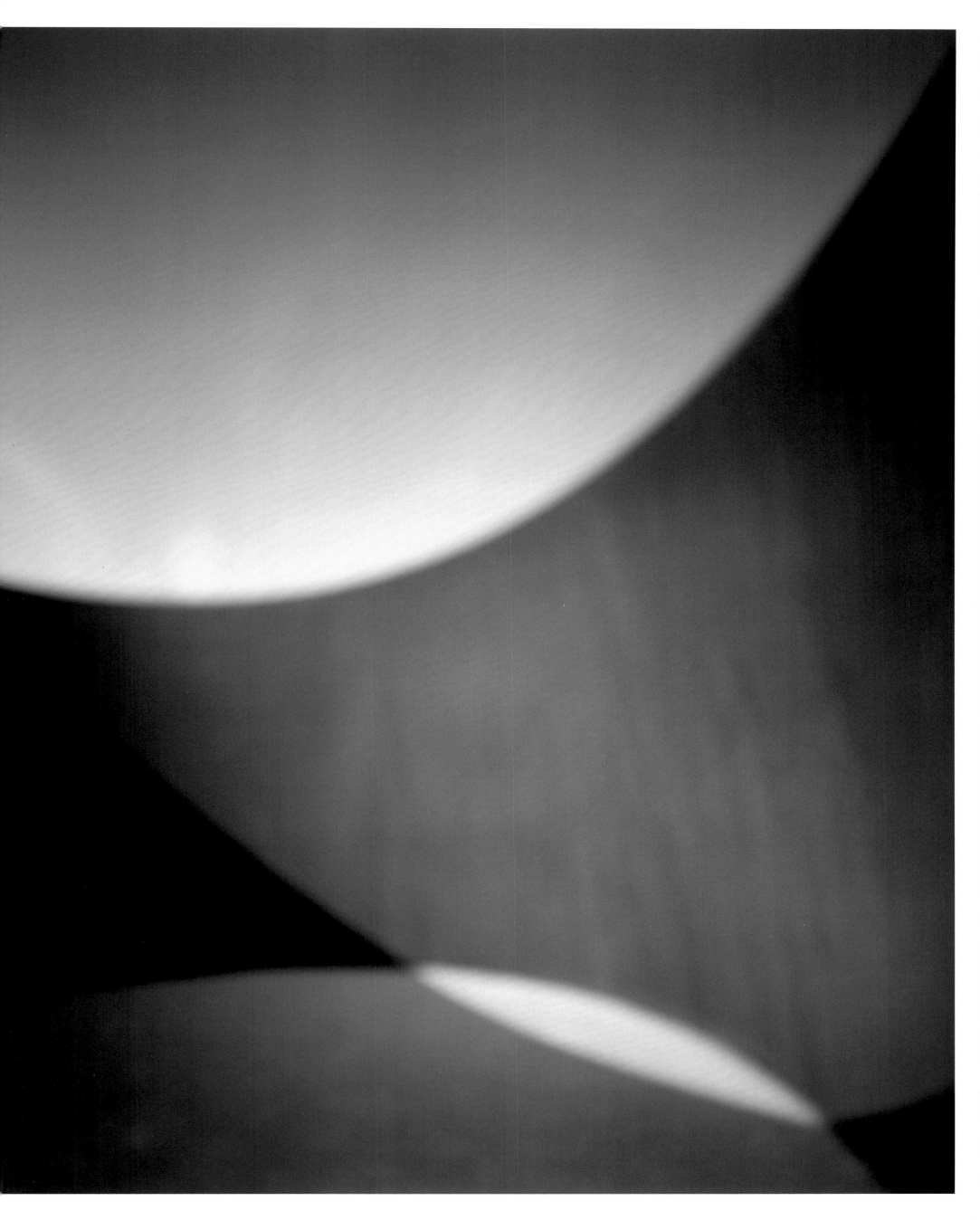

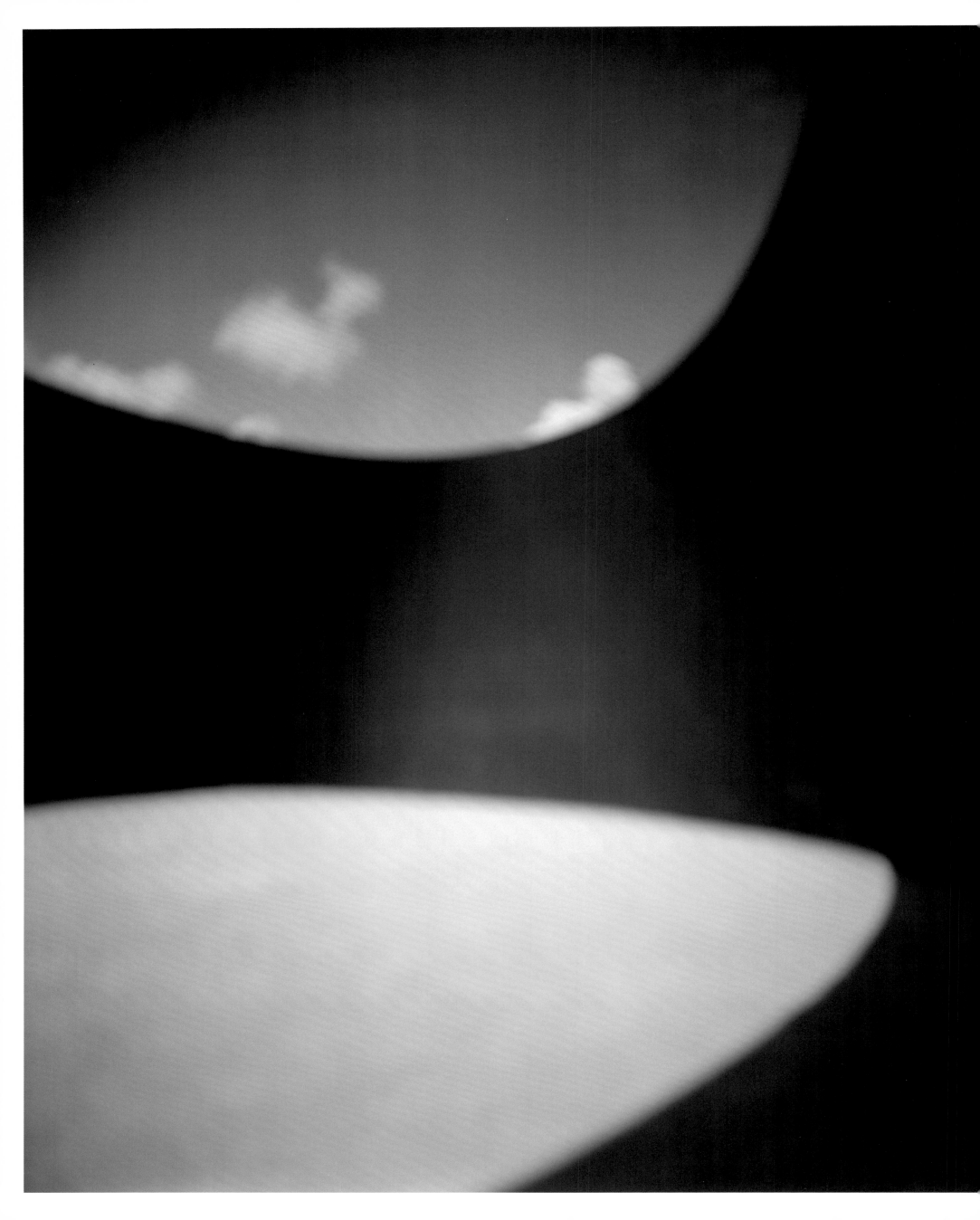

At the sink, her hands still in the water,

she resolved to start carrying

a little book for ideas

that might otherwise be lost.

Because lost ideas are converted

into the feeling of loss.

On the first page she wrote,

"There is a world without sound."

A few weeks after Joe learned of his illness,

the family went to the beach.

The ocean was yellow and blue.

Joe turned and saw his daughter's footprints.

He had never been happier.

Could he have been as happy if he were any less sick?

He took a Polaroid of the ocean.

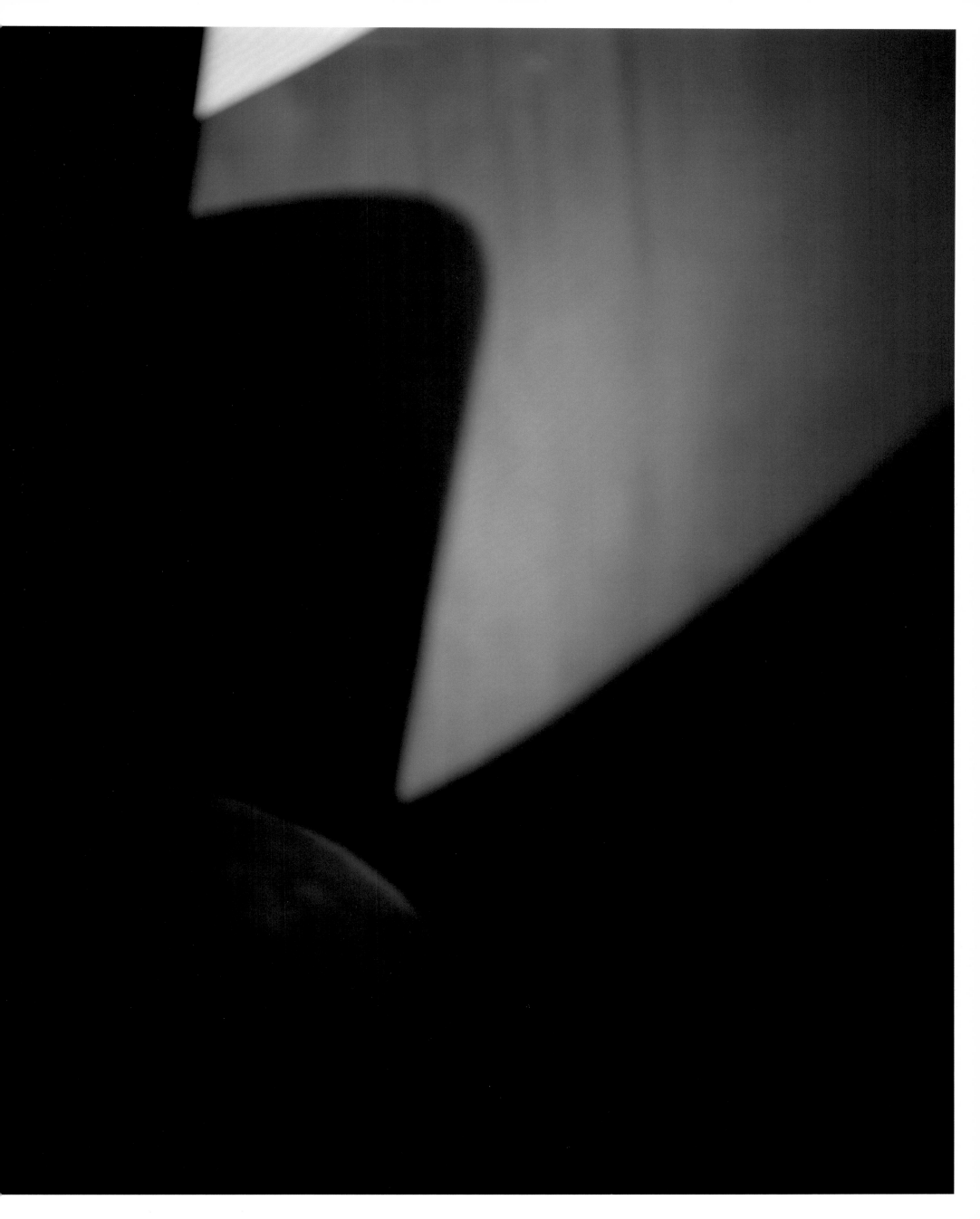

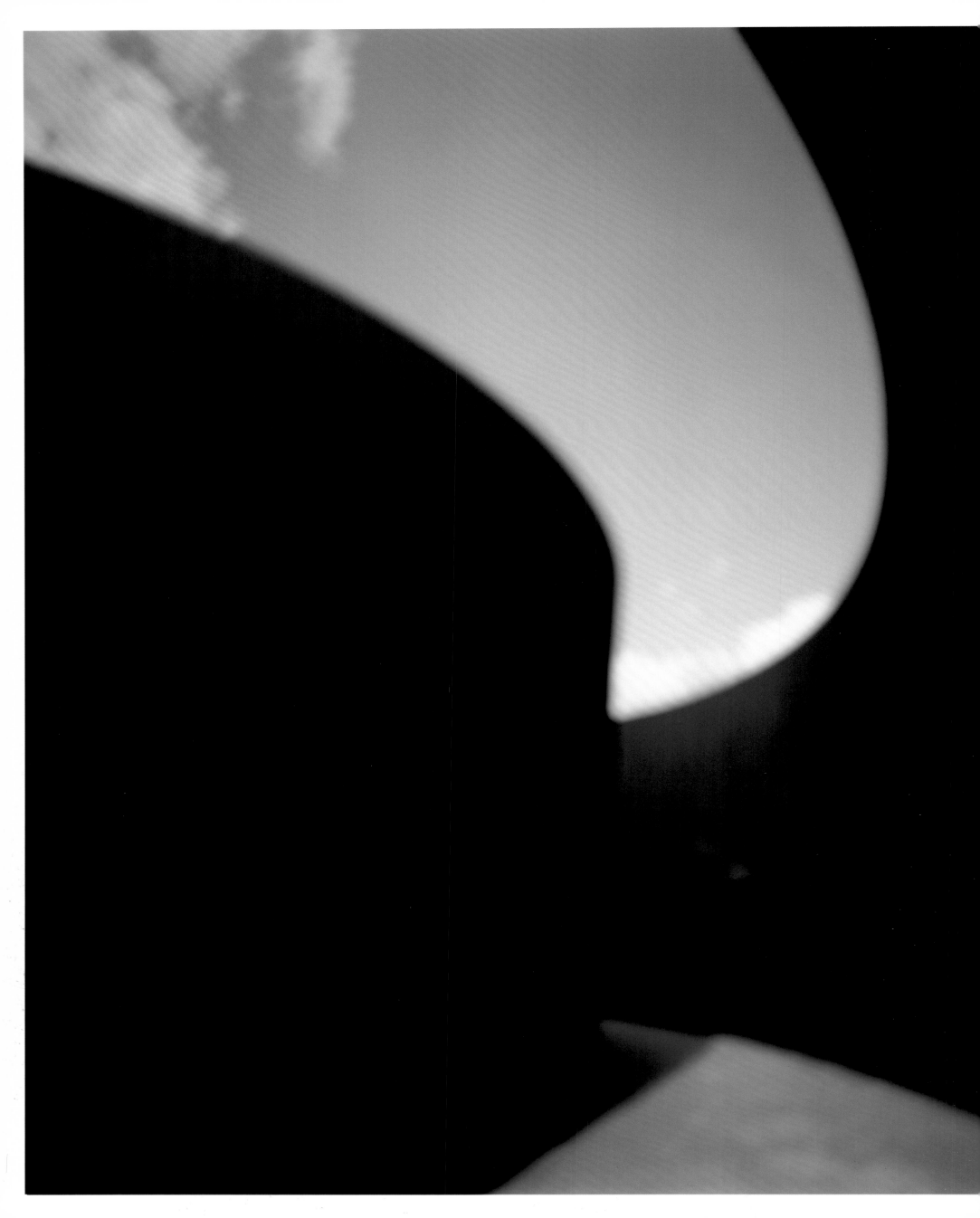

He pulled the picture from the camera,

and put it in one of the chest pockets

of his favorite jacket—

the image facing in.

The heat of his body brought

the waves out of the chemicals.

Or so Joe assumed.

As he sews that pocket shut,

almost two years later,

it occurs to him that no one

has seen the photograph.

There is a world in which silences are embodied.

The silence between a husband and wife

might take the shape of a kitchen window,

or a pocket watch,

or an ocean in a pocket.

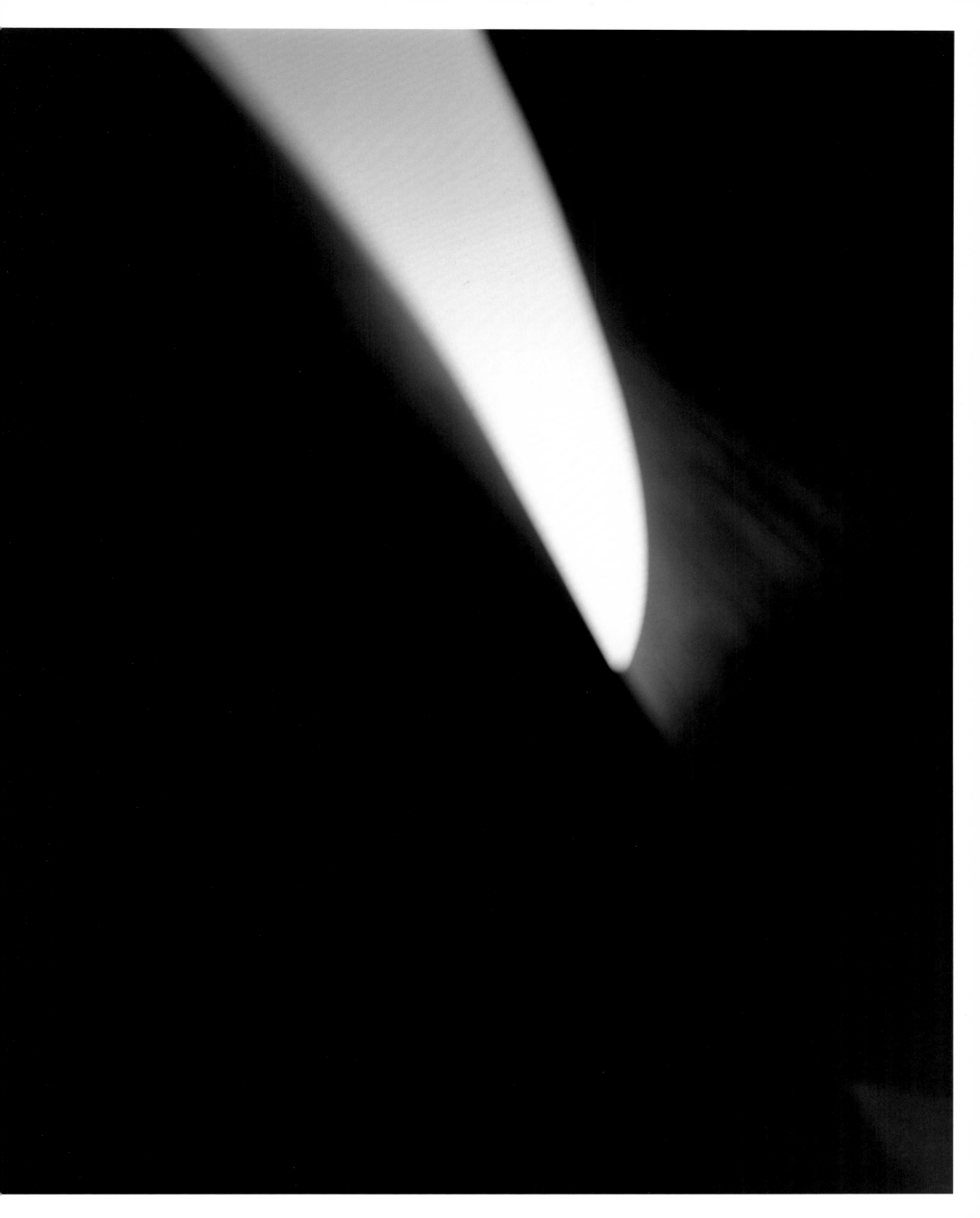

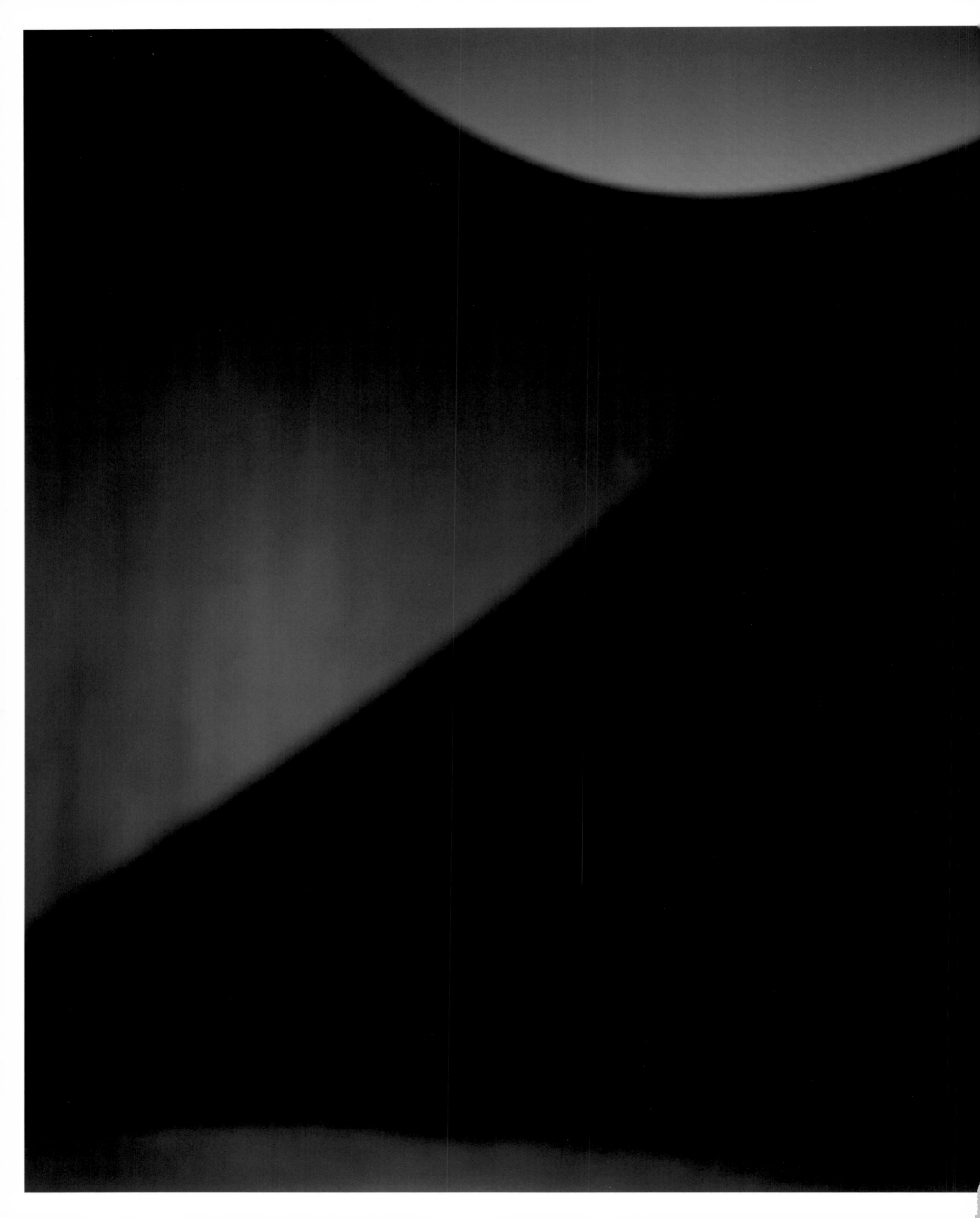

Joe can hear his wife in the garden.

Why won't she come in and sit with him?

He thinks about writing a letter to someone

he hasn't been in touch with for years.

He thinks about phoning a wrong number,

or his daughter.

He's suddenly struck by a fear

that there are thousands and thousands

of things he needs to do.

He buys an empty book at the stationery store.

Joe turns on the sink when he goes to the bathroom.

He's been married for thirty-seven years.

Joe doesn't like buying suits—

too many mirrors.

He has never once sent back a wine.

He has never once said anything other than "Great"

to a barber at the end of a haircut—

too much to explain.

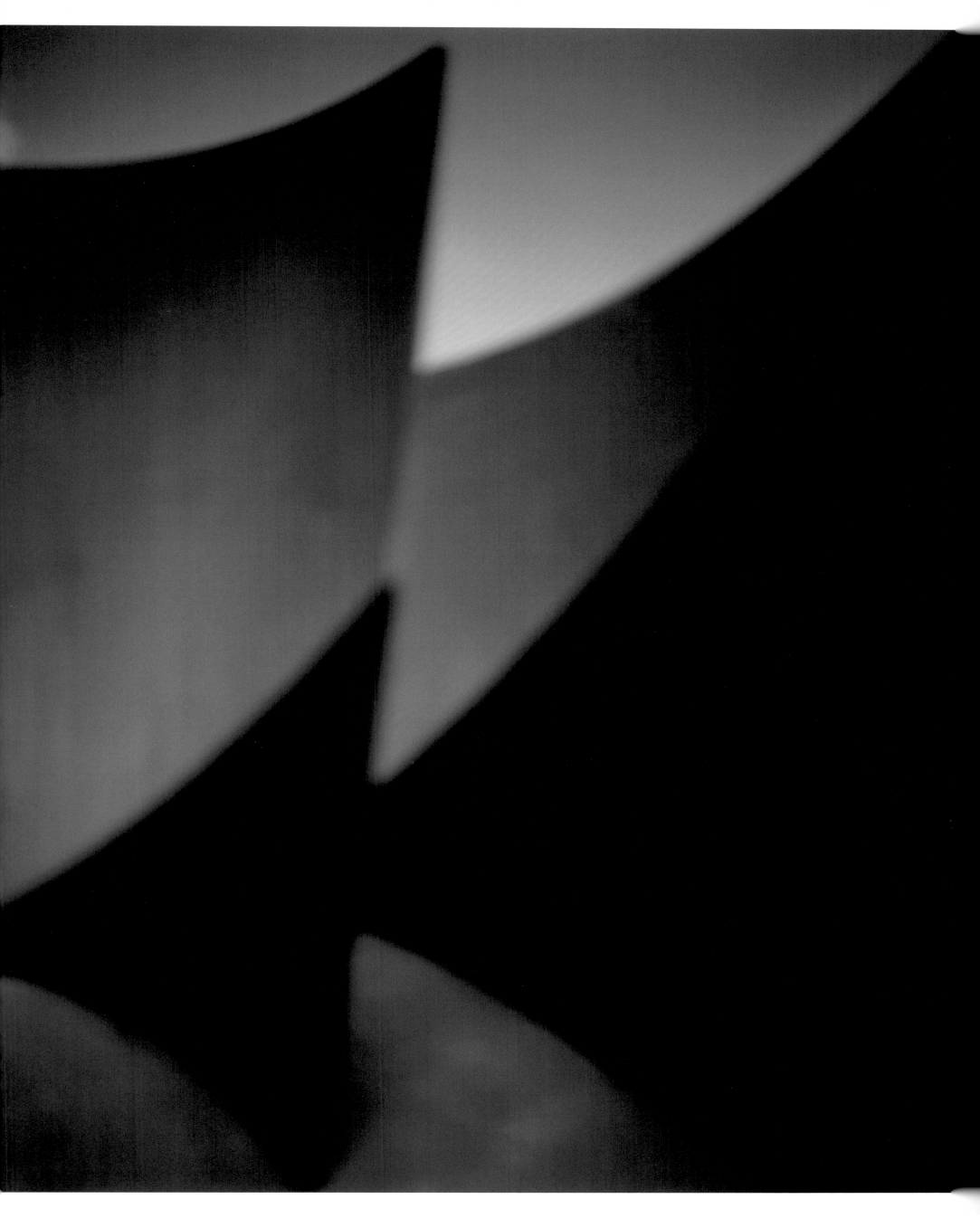

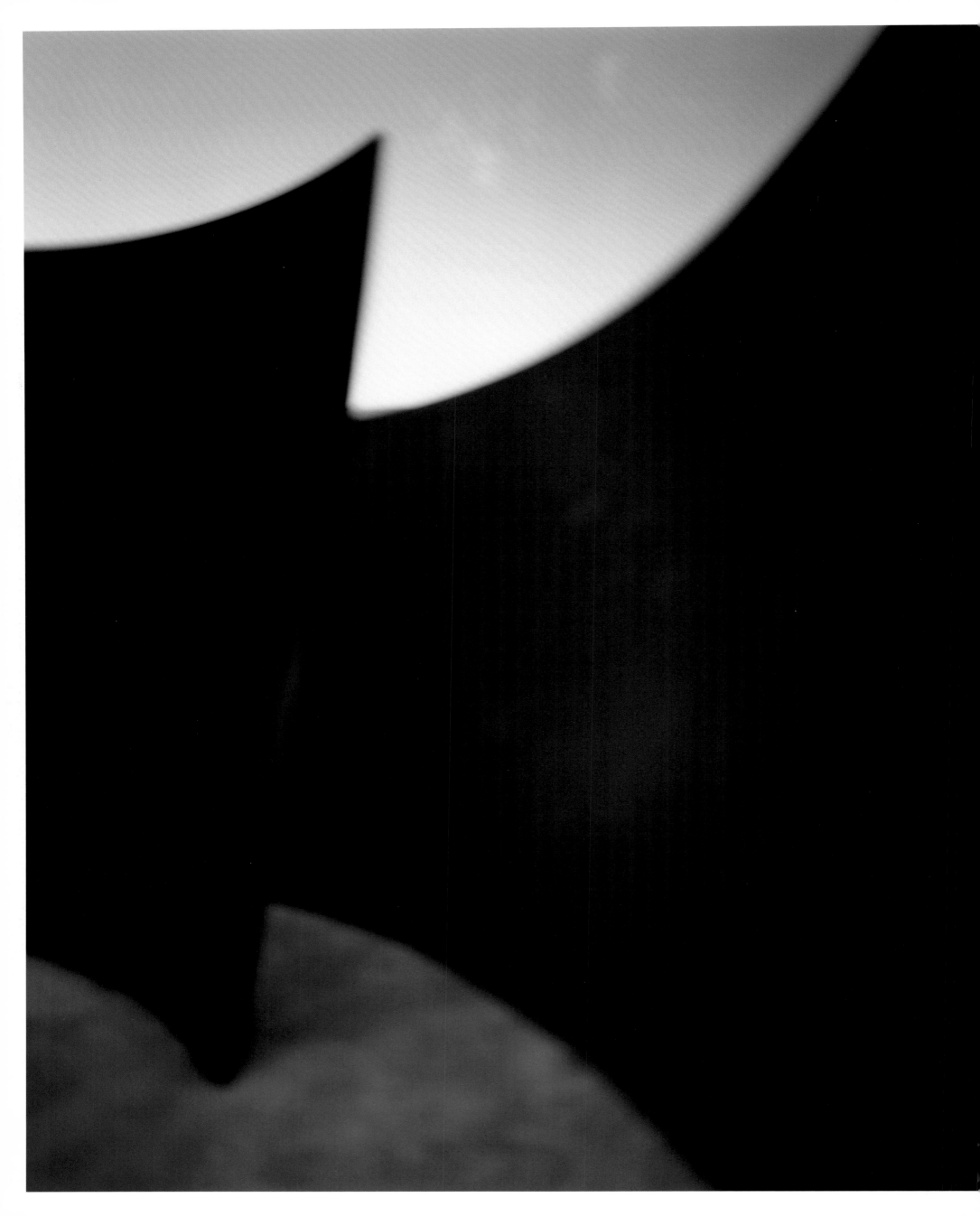

Tell the barber it isn't right,

even if you can't explain what isn't right.

Send back a bottle of wine.

Say no to a magician.

Go through your address book

and apologize to everyone you've ever known.

For her sixth birthday,

Joe took his daughter to a magic show.

He spent the performance fearing the magician

would call him up on stage.

How could he say no?

And why does he turn on the water

even when no one else is in the house?

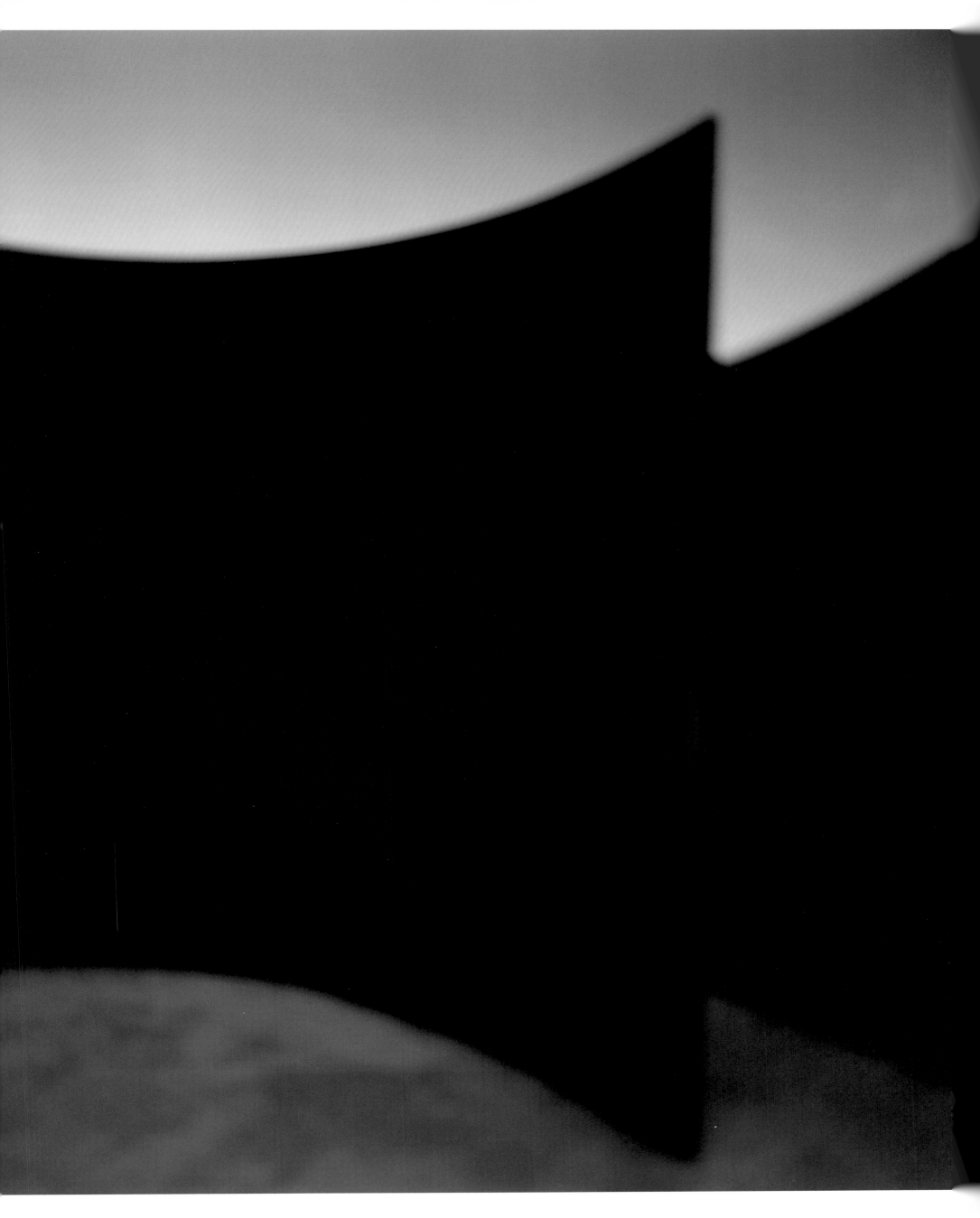

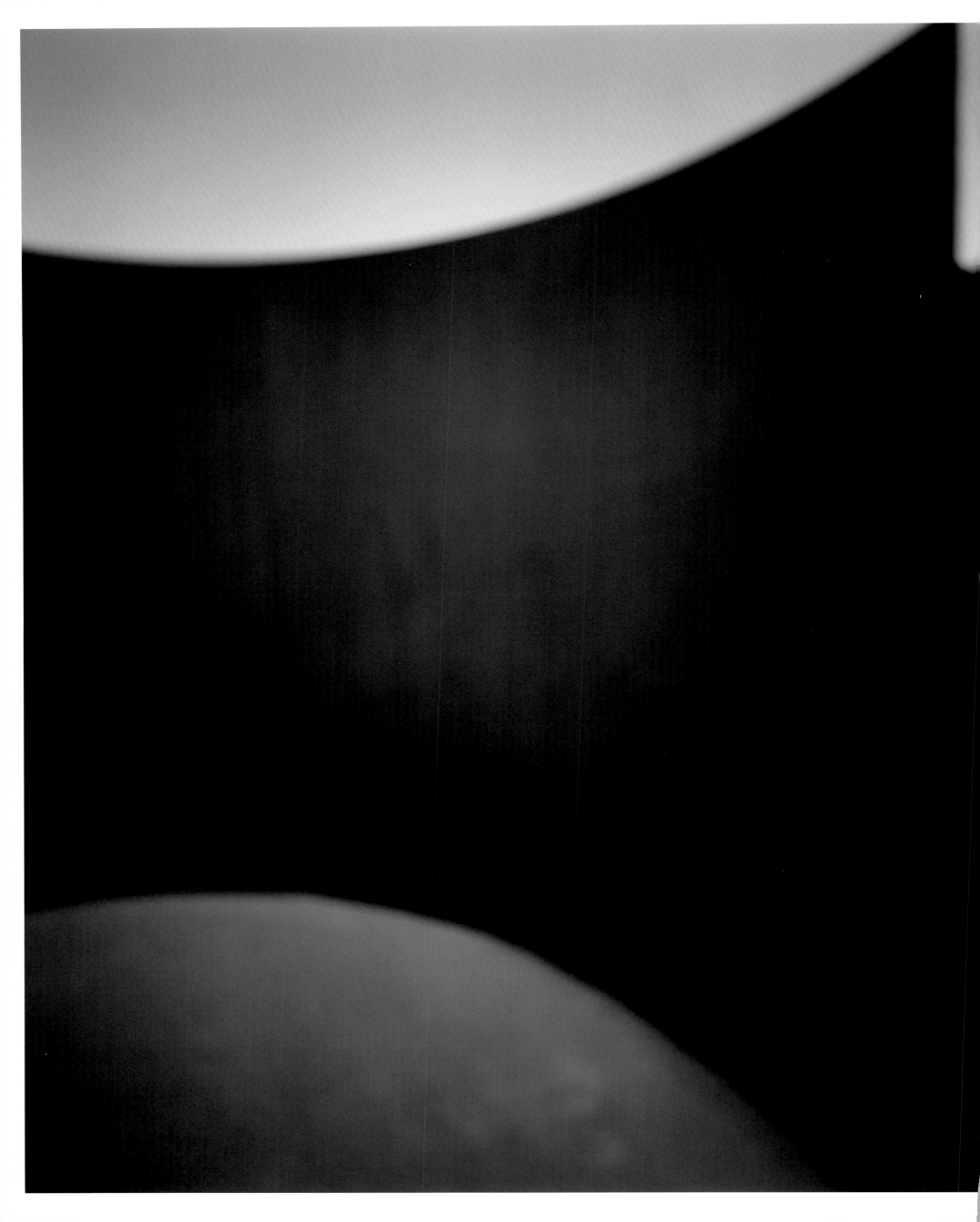

A new battery,

in an old pocket watch,

in a pocket stitched shut.

Everything happens backward.

Words go into people, instead of coming out of them.

The edge of a sheet of paper heals a paper cut.

Roosters announce darkness.

A painter removes green waves from a canvas,

and applies them to his palette.

And then, on his palette,

he separates the waves into yellow and blue.

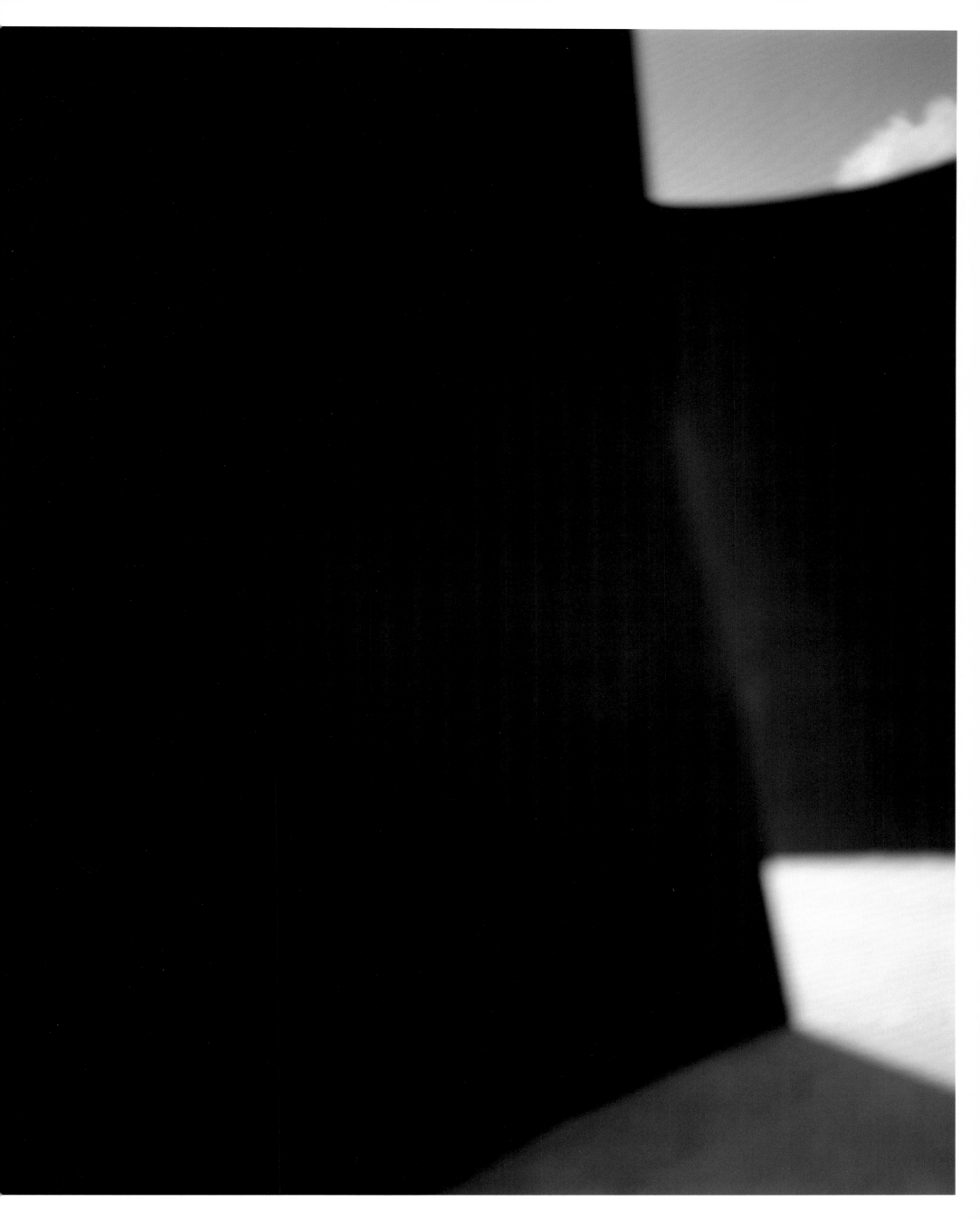

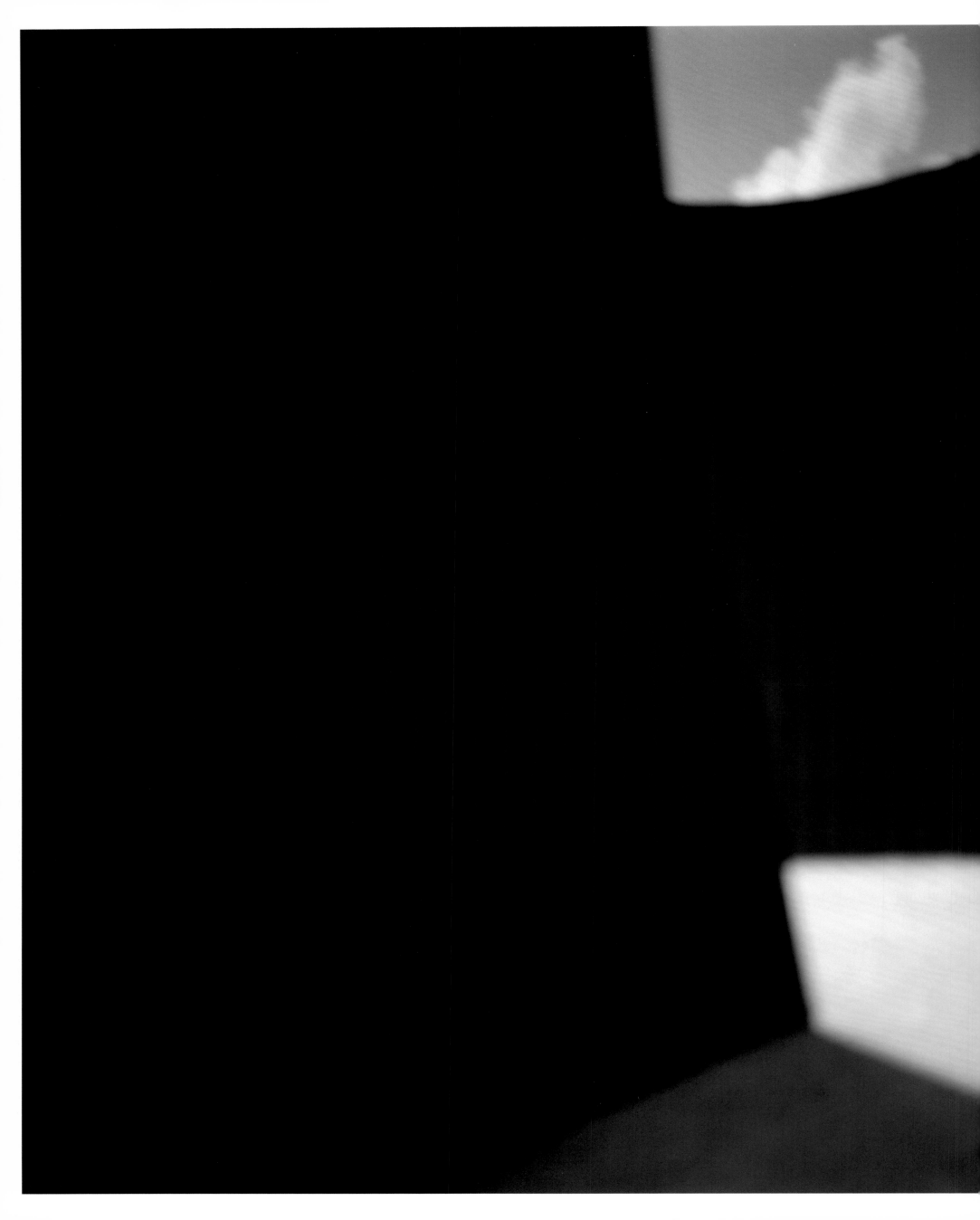

Joe and I know each other

less and less as time passes.

The end of every day

is the beginning of every day.

I watch him spit coffee into his mug,

put hair on his face with a razor,

wake up and get into bed.

Eventually we'll be young again.

One day we'll only barely know each other.

We'll drive backward

in what will become your new car

to the beach where we first slept side by side.

The green waves will go back into the ocean,

yellow and blue.

You'll pull up my underwear.

I'll button your shirt.

We'll dress and dress and dress.

Then we'll step into our footprints

and erase our trail.

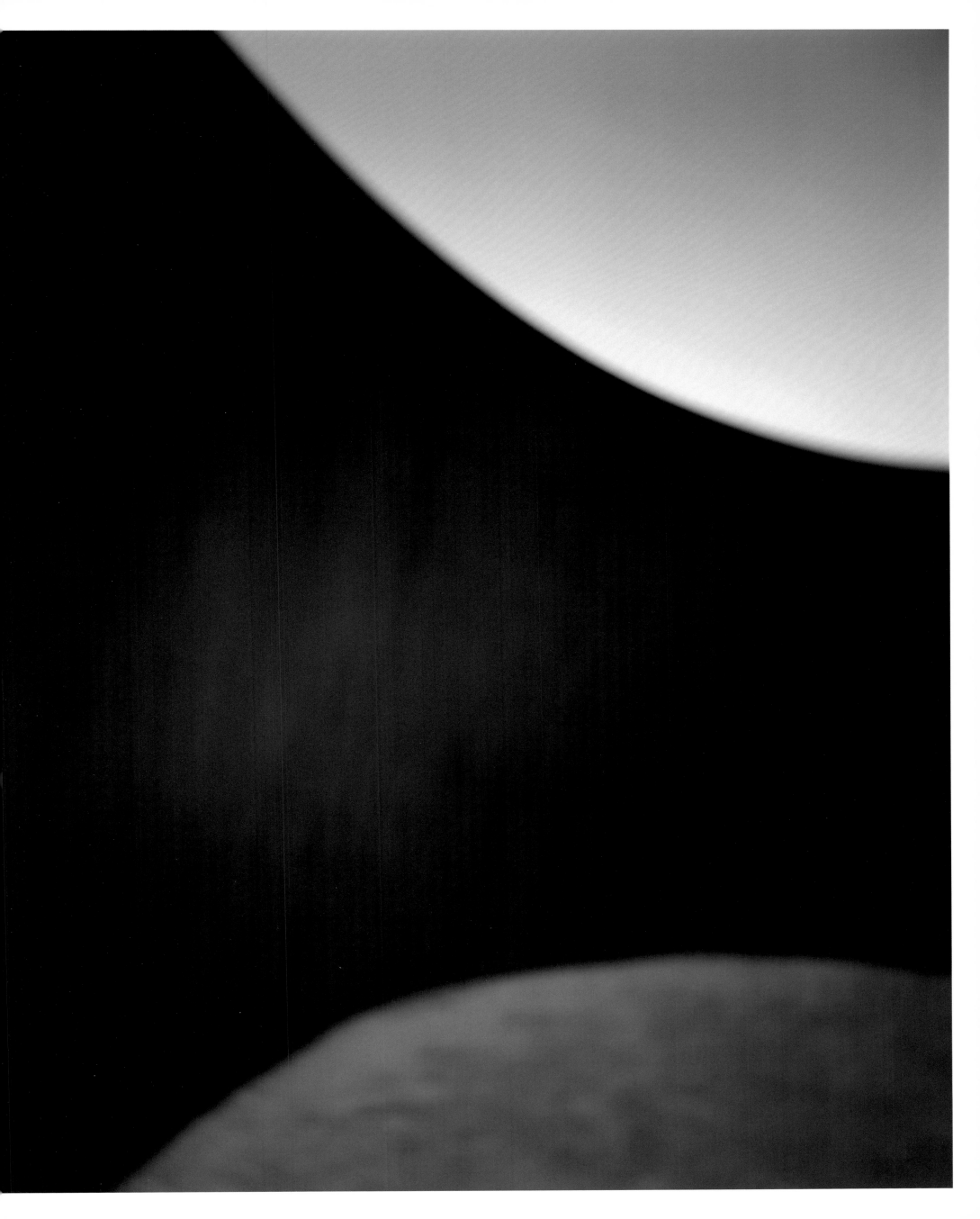

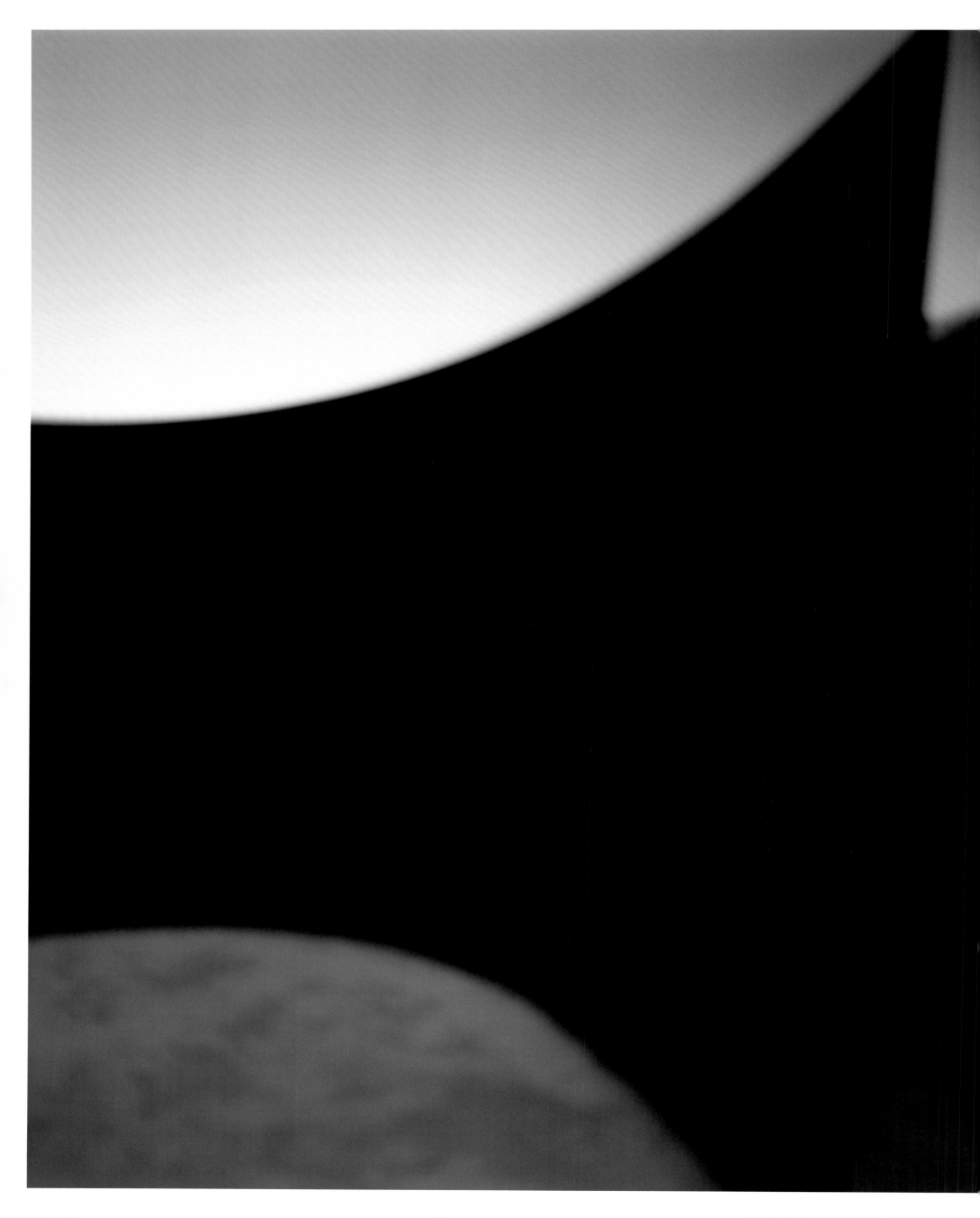

"Hi. It's Joe.

I'm calling to apologize for something

that happened a long time ago."

"Oh, I'm sorry. I must have

dialed the wrong number."

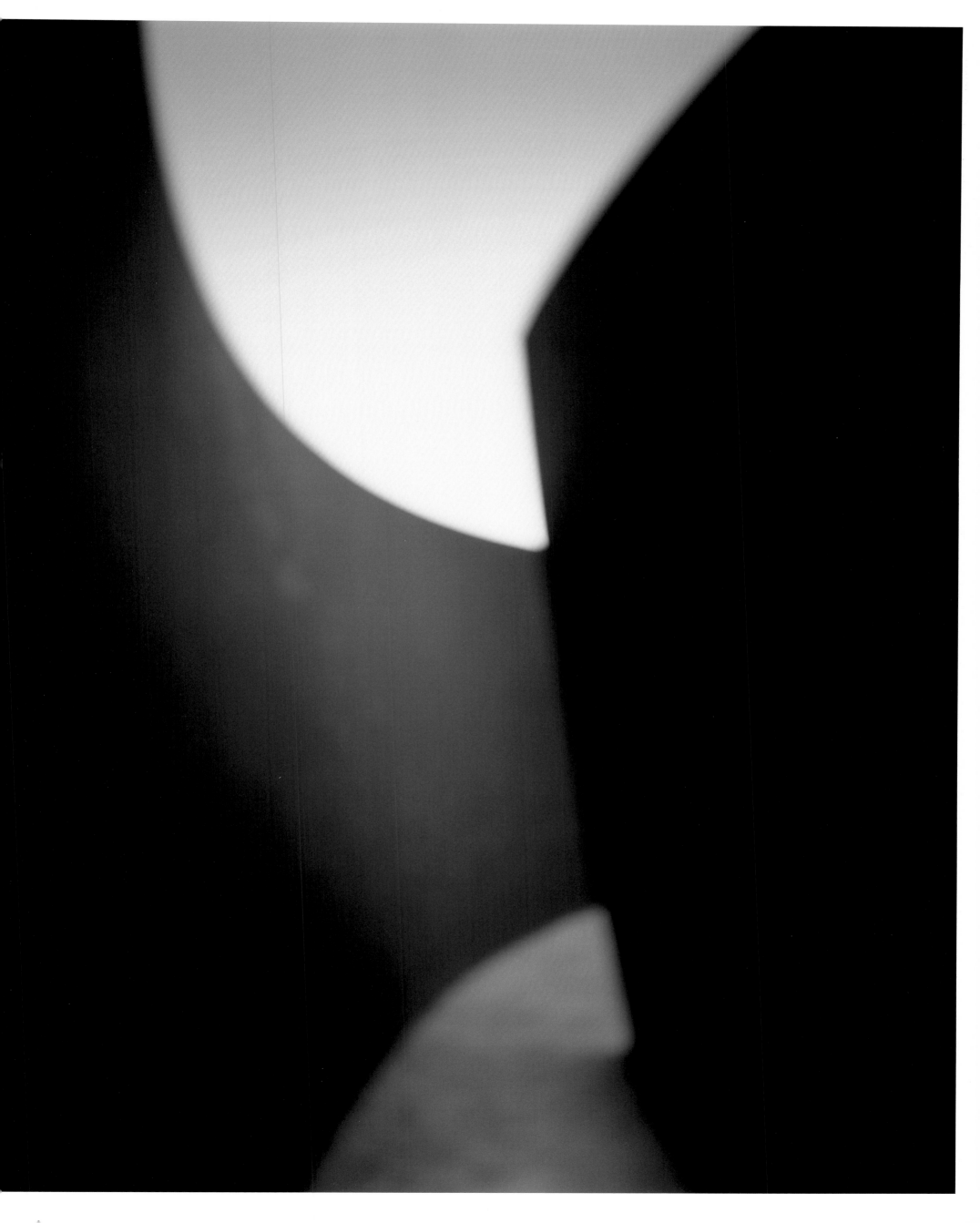

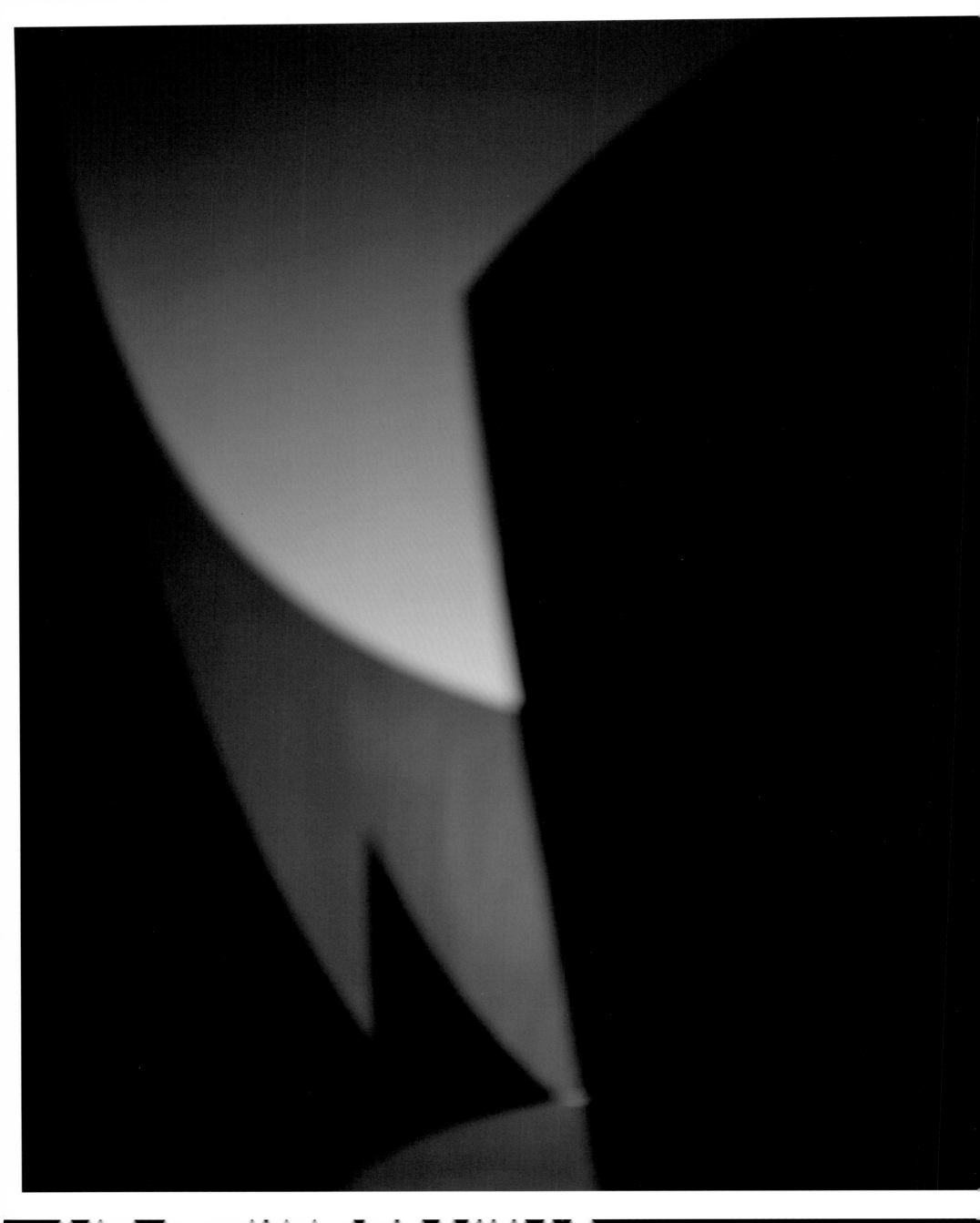

Build a wall around the yard,

something solid and high.

Put the loose pictures in albums,

or throw them away.

Buy a new battery for the pocket watch.

Drop off dry cleaning that you'll never pick up.

Pay the accountant in advance

for the estate work.

Find out what happened to those other babies

in the maternity ward.

They were taken in different cars,

by different parents to different homes,

to live different lives.

Maybe she's passed one of them on the street

without knowing it—shaken one of their hands,

argued with one of them about something

that neither of them cared about.

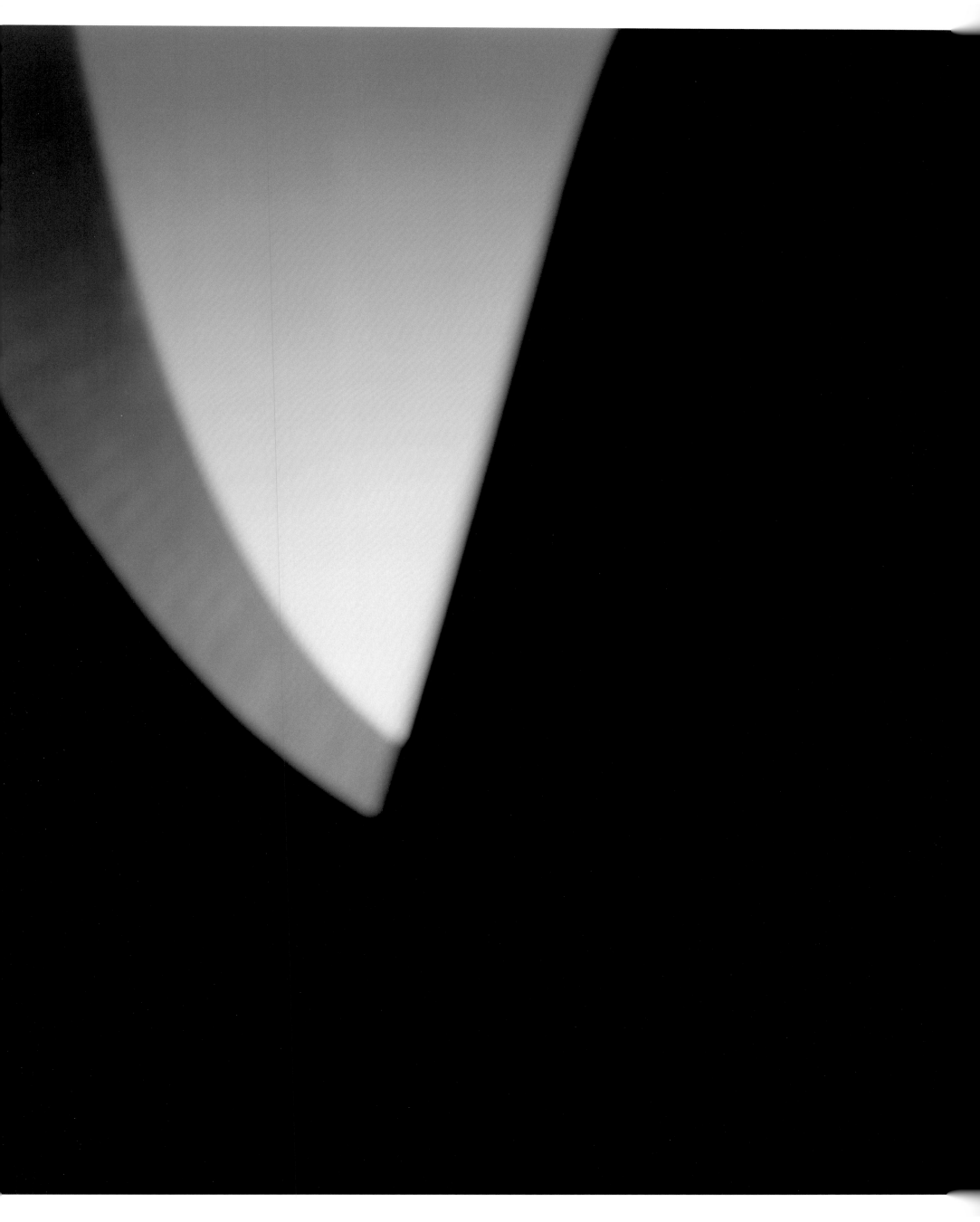

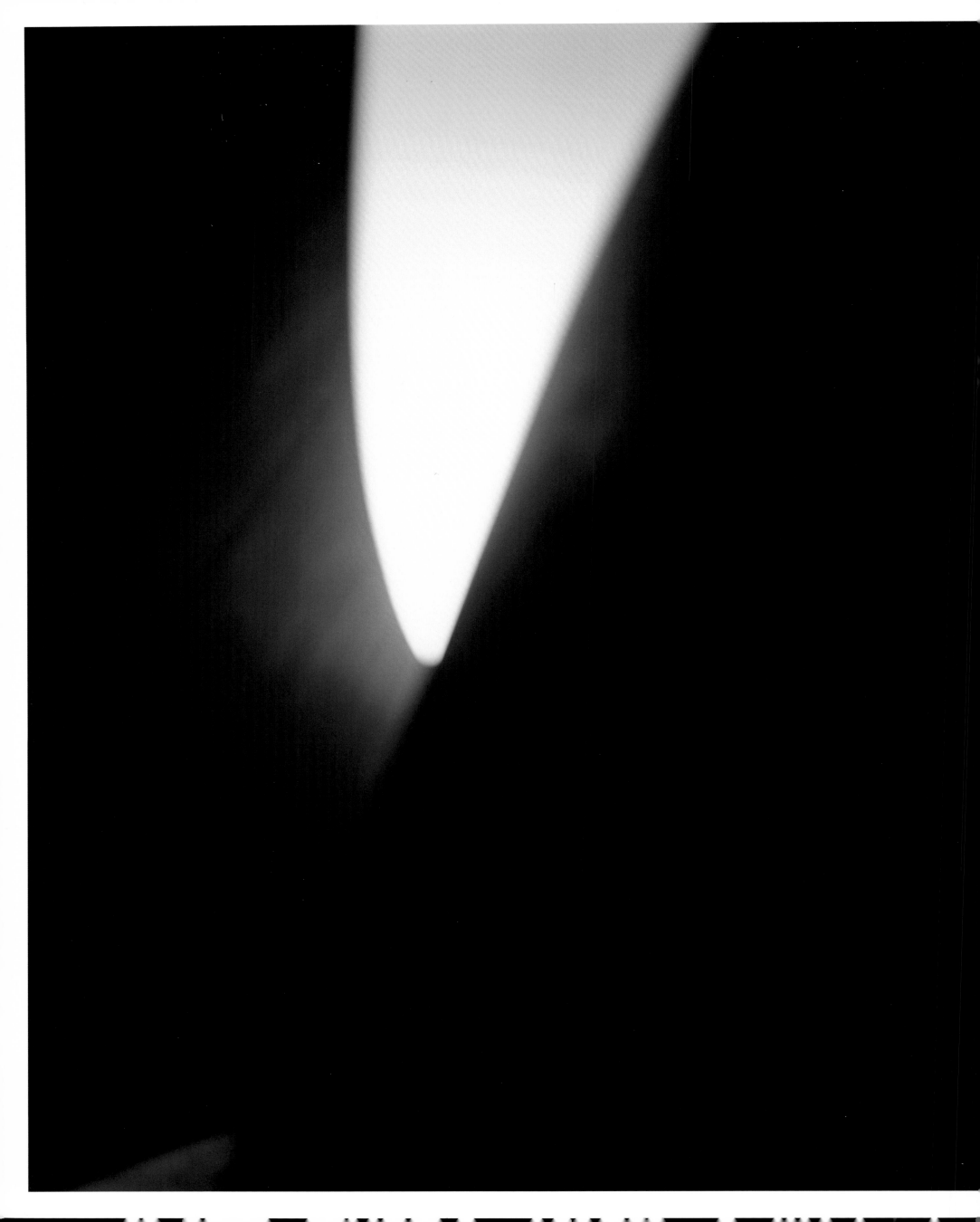

Words leave stains, Joe.

Some words are like lipstick around the end of a cigarette,

and some are like wine across a tablecloth,

and some are bloody.

Stained glass is always installed clear—

prayers are colorful

—and no one knows what telephones really look like.

Some stains can be washed away,

some stains are permanent.

It's hard falling asleep next to you.

I'm sorry for yesterday.

When you said, "That's not who I am,"

it stained my wrists silver,

so I hid them in the soil.

When I confessed my anger,

I saw what you couldn't see:

green rings around your neck.

When you told me you weren't afraid,

I told you I was.

You told me you loved me,

I told you never to say that again.

We became flesh-colored.

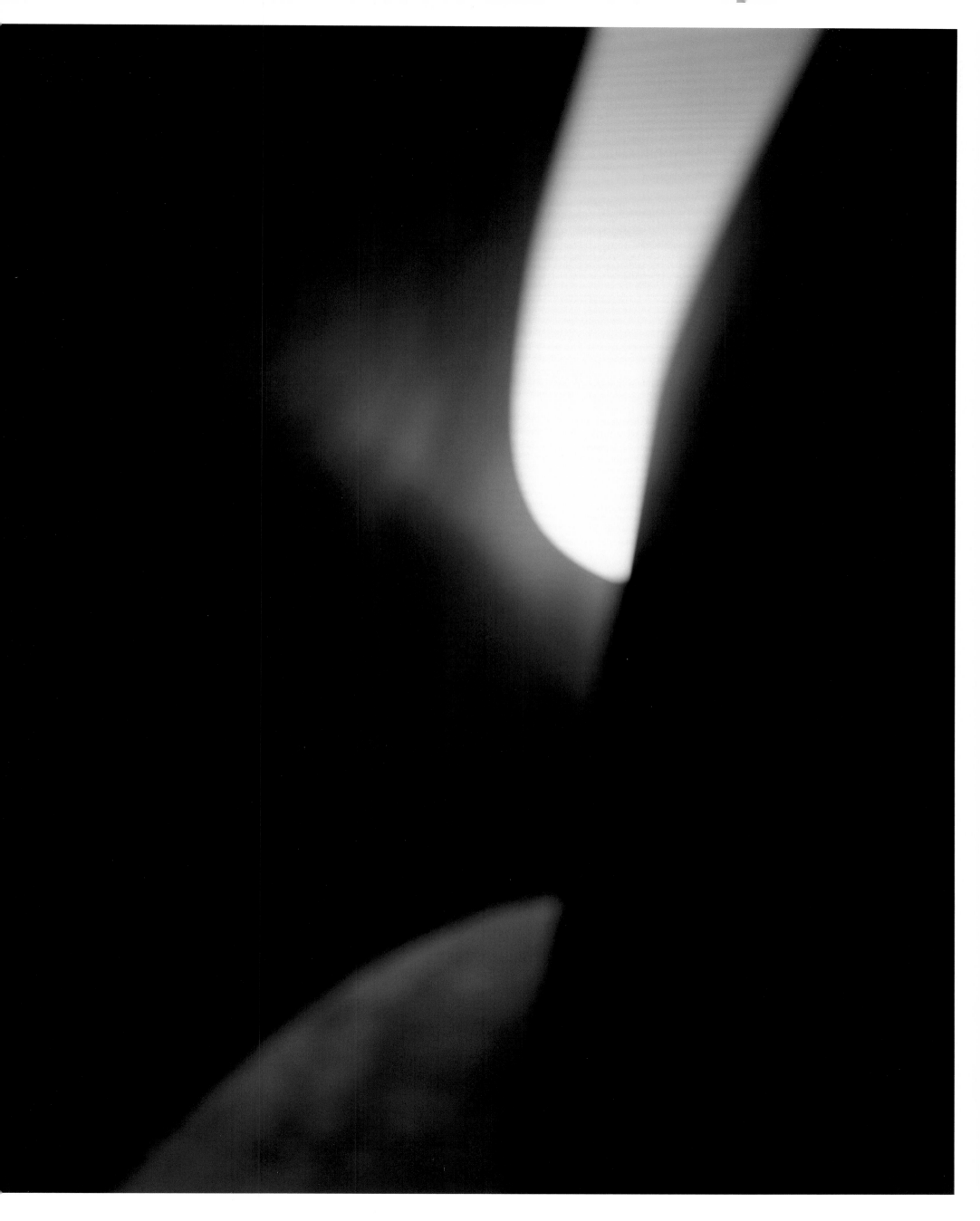

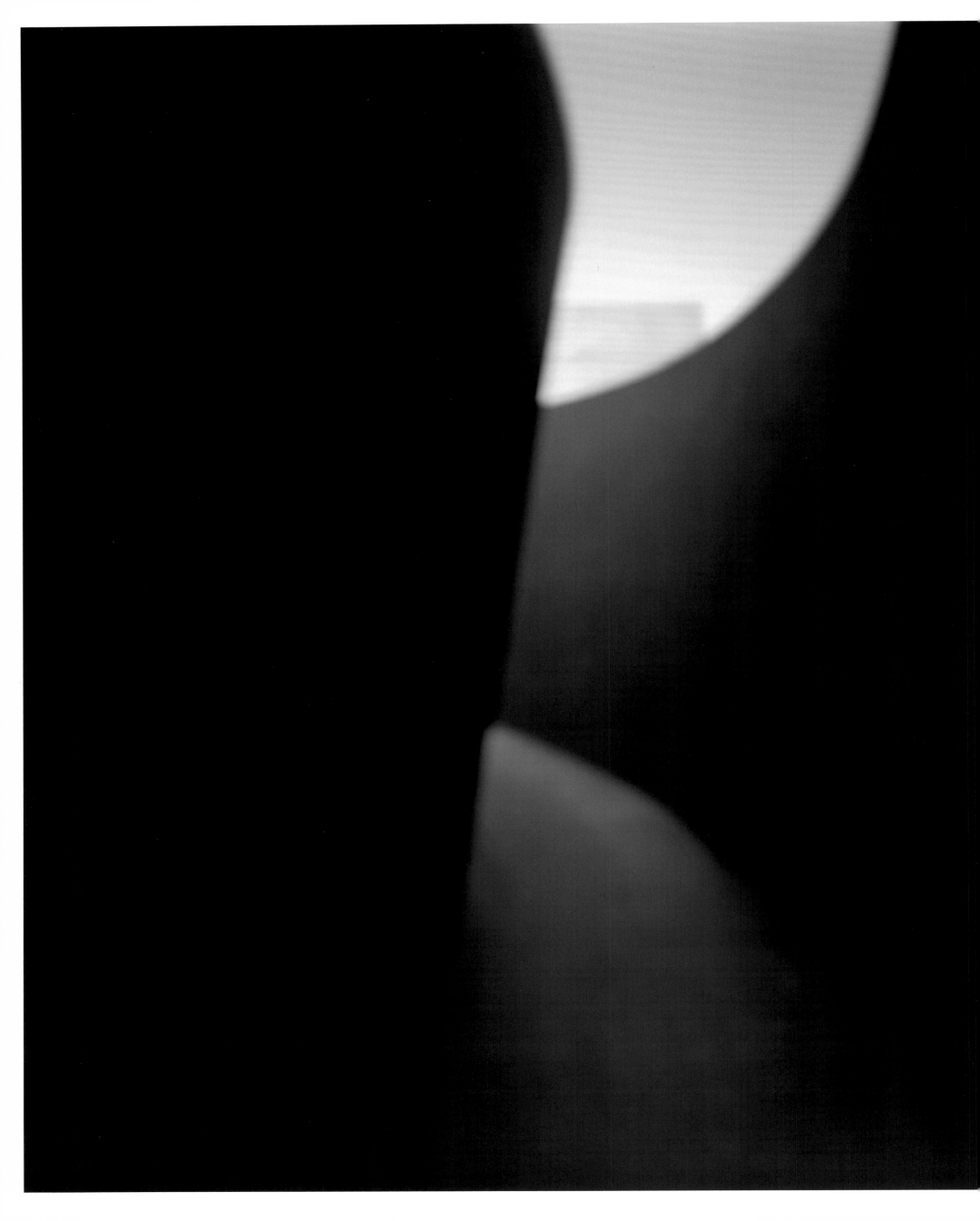

And what about the children

she went to nursery school with?

Where did they go?

What about the girl who used to babysit

when we went out for dinner with friends?

What happened to her teachers?

What happened to the man

who sold me her first bike,

whose seat I held as she rode

until I let go?

There are boyfriends

she will never see again.

No one has spent as much time

with her as I have.

And there is a world in which you can see what people are thinking.

Some people carry bank vaults over their heads,

and some commas and parentheses,

and some the naked image

of whomever they are looking at,

or of someone else.

Some carry birds as they look at eggs,

and some pine trees being cut down for coffins

as they watch grooms stamp crystal beneath their feet.

Others carry nothing.

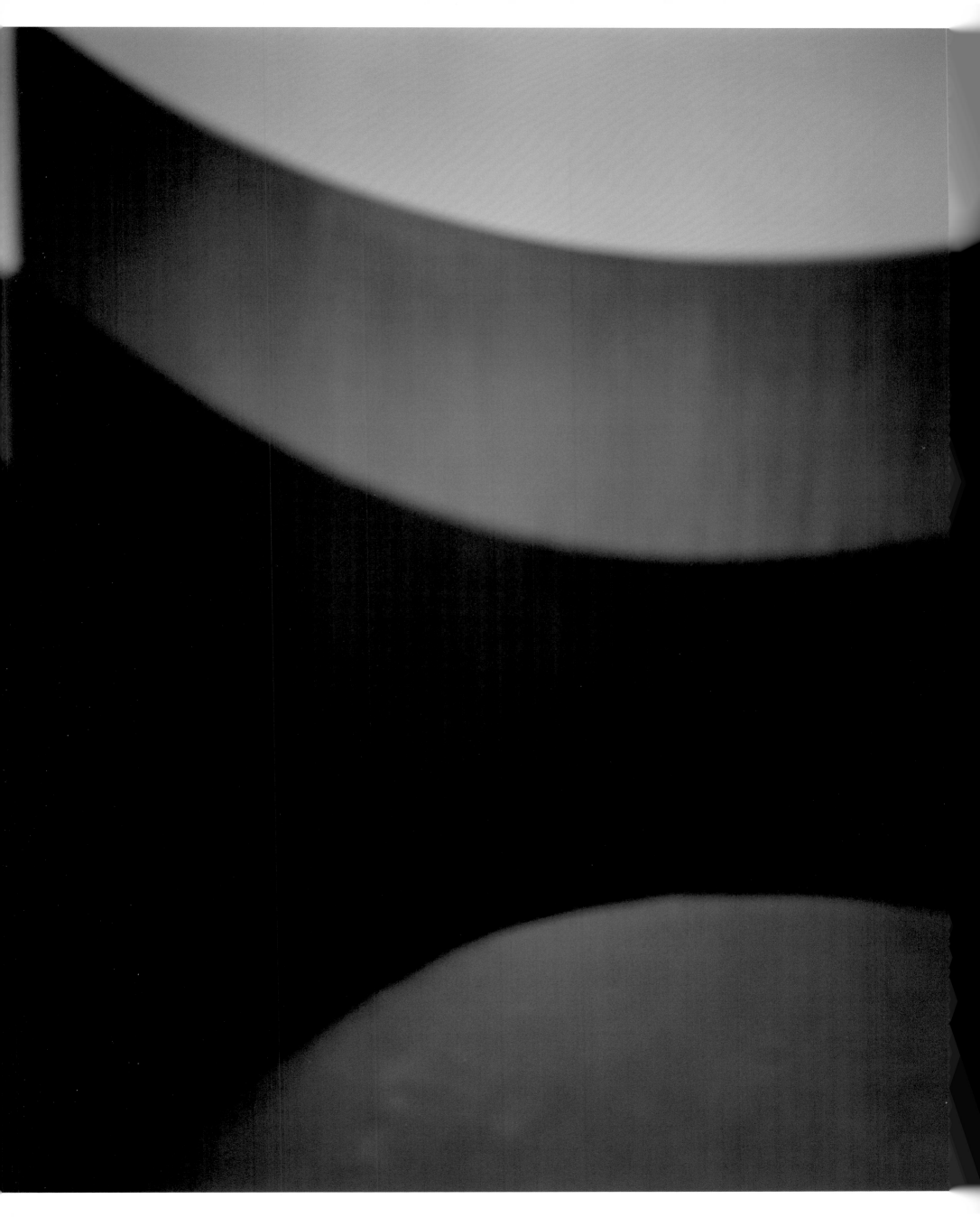

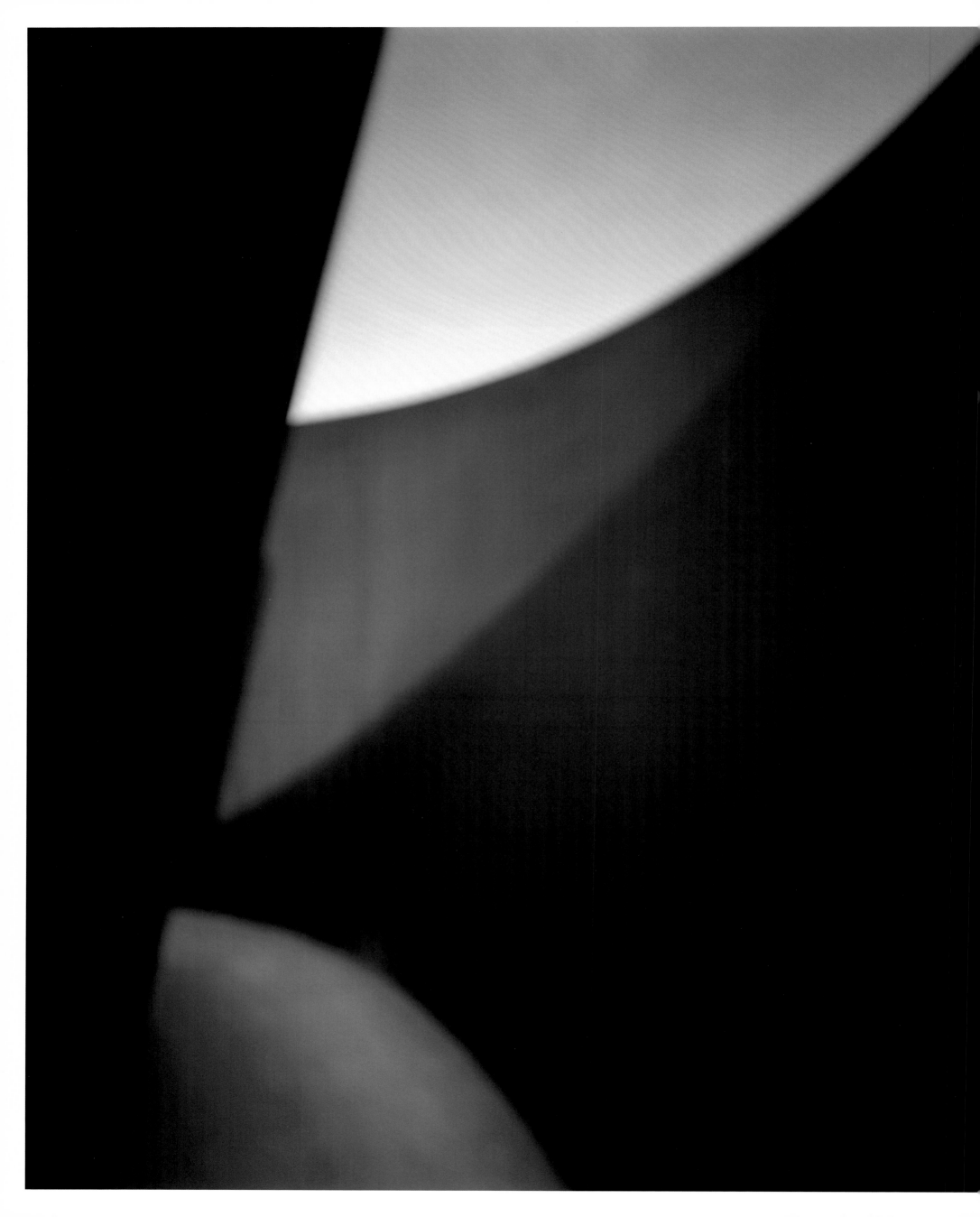

What about the people

who will be near me in the ground?

Have I ever passed one of them on the street

without knowing it?

Shaken one of their hands?

Argued with one of them about something

that neither of us cared about?

Some people won't go out in public,

fearing what others might see them think.

Some won't stay inside.

Some pin their lovers against walls

and point at what they're thinking

and apologize,

or wait for apologies.

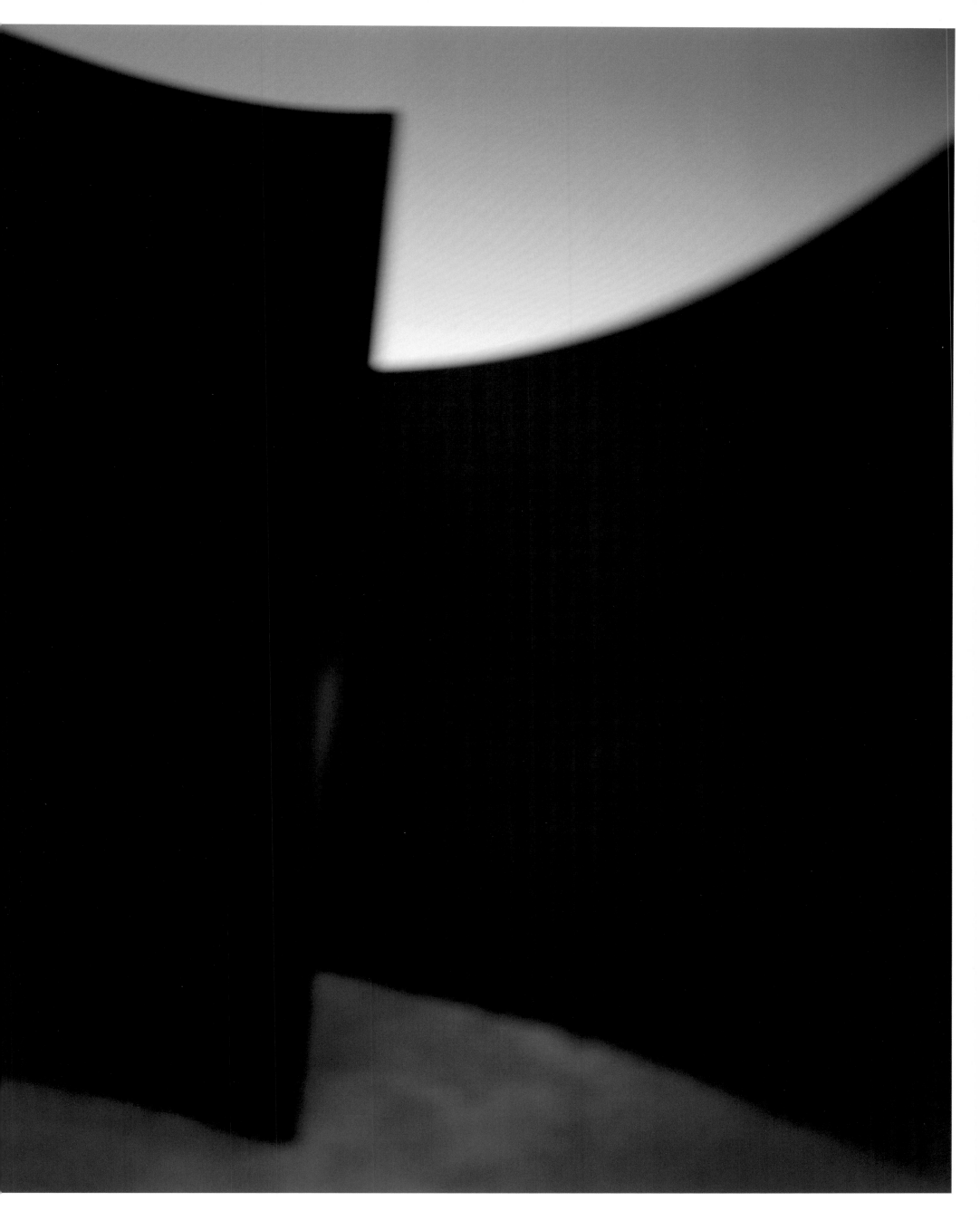

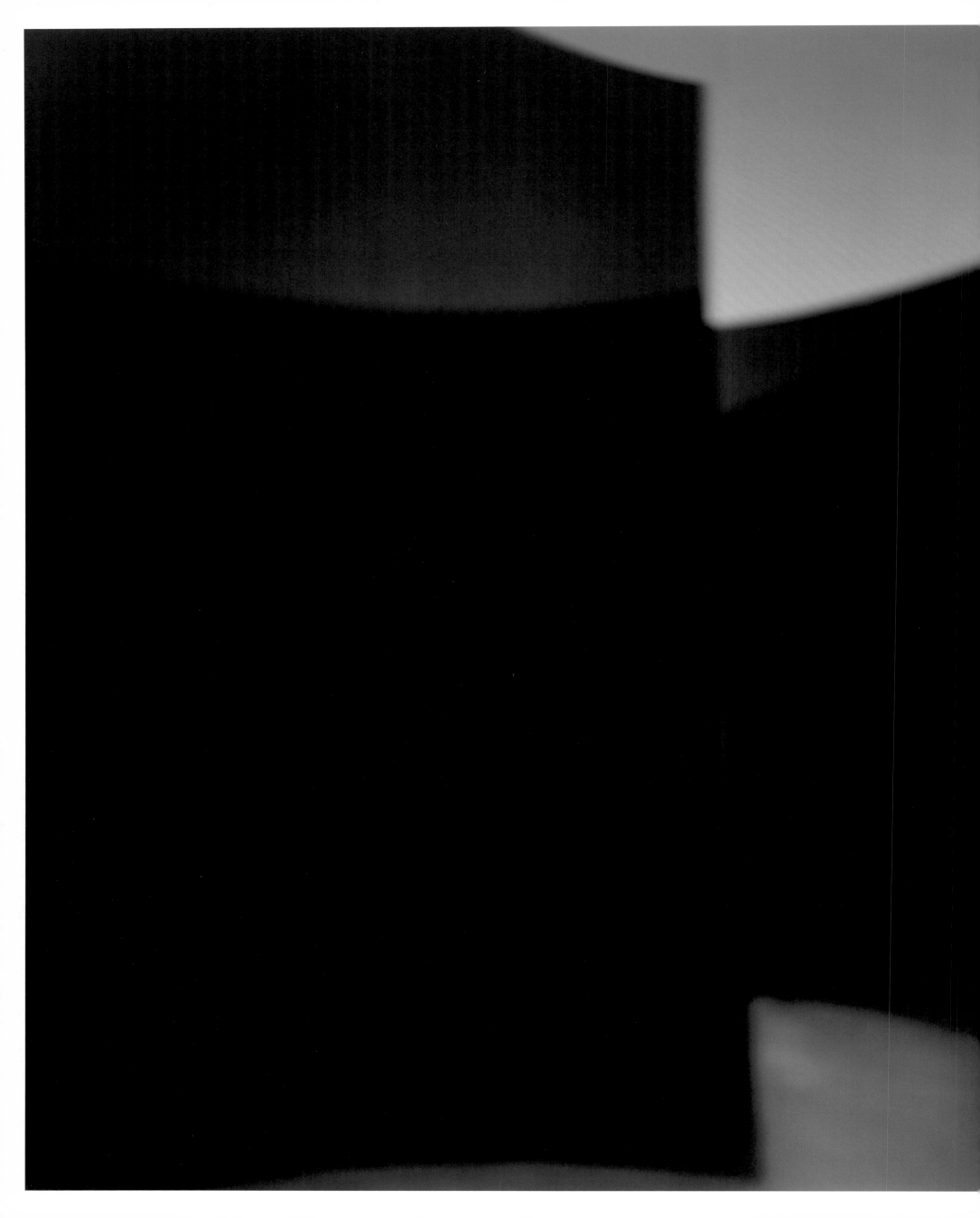

Joe puts down the needle and thread

and goes out into the garden.

He doesn't know what he needs to tell her.

He only knows the need.

Her arms are buried in the soil.

There is wet dirt on her cheeks.

He gets on his knees, beside her.

Look at what I'm thinking.

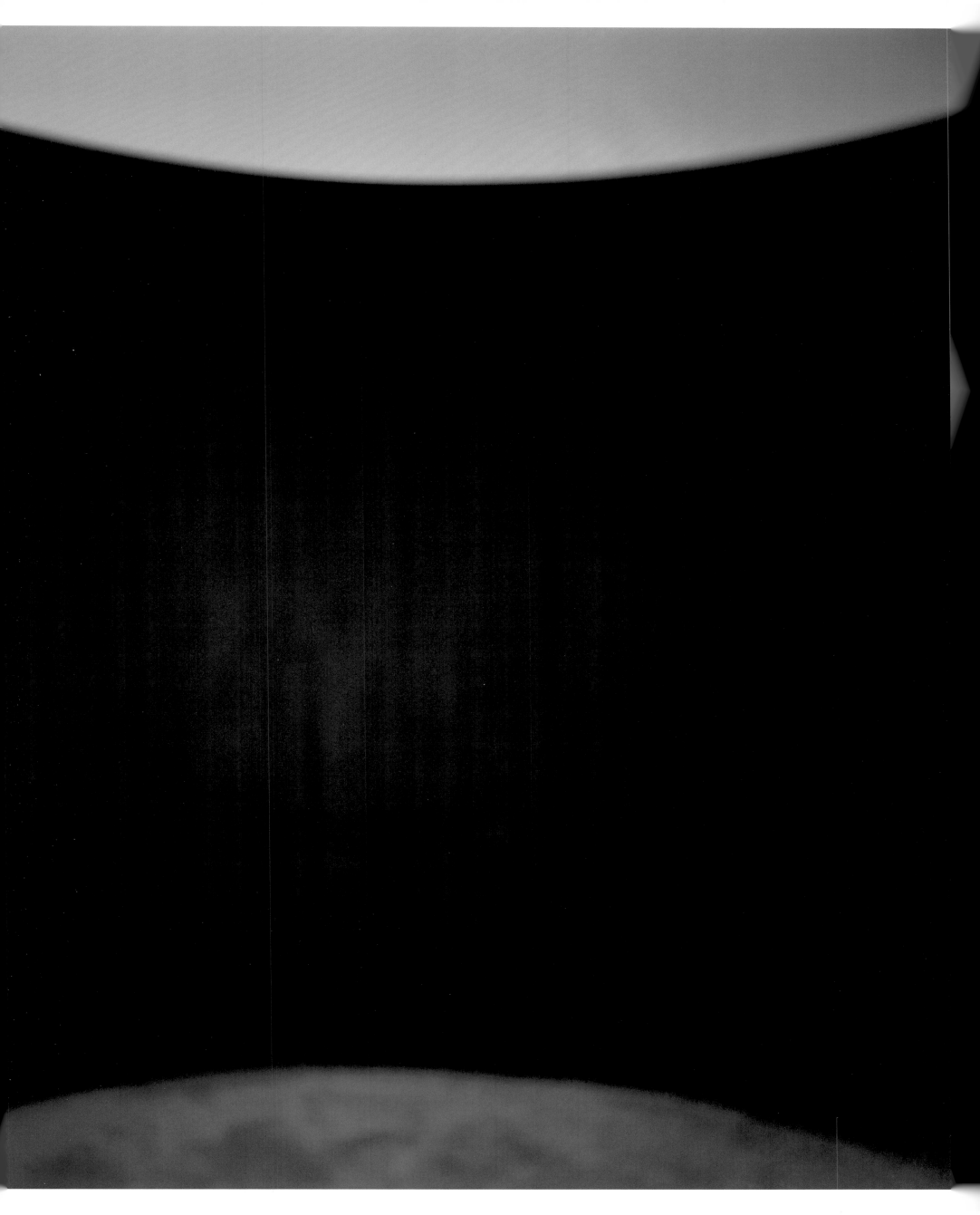

All photographs are gelatin-silver prints, 58 ¾ x 47 inches (149.2 x 119.4 cm), edition of five.

† shown at The Pulitzer Foundation for the Arts

Published by
The Pulitzer Foundation for the Arts
3716 Washington Boulevard
St. Louis, MO 63108

ISBN 3-7913-3689-4 (Prestel Publishing)
ISBN 0-9714648-3-9 (The Pulitzer Foundation for the Arts)

Designer: Takaaki Matsumoto, Matsumoto Incorporated, New York
Project Manager: Amy Wilkins, Matsumoto Incorporated, New York
Tritone Separations: Robert J. Hennessey
Printing and Binding: Mariogros s.p.a., Turin, Italy

Distributed by:

Prestel Verlag
Königinstrasse 9, 80539 Munich
Tel. +49 (89) 38-17-09-0 Fax +49 (89) 38-17-09-35

Prestel Publishing Ltd.
4, Bloomsbury Place, London WC1A 2QA
Tel. +44 (020) 7323-5004 Fax +44 (020) 7636-8004

Prestel Publishing
900 Broadway, Suite 603, New York, NY 10003
Tel. +1 (212) 995-2720 Fax +1 (212) 995-2733

www.prestel.com

Library of Congress Control Number: 2006901821

British Library Cataloguing-in-Publication Data
A catalogue record for this book is available from the British Library.

The Deutsche Bibliothek holds a record of this publication in the Deutsche Nationalbibliografie;
detailed bibliographical data can be found under: http://dnb.ddb.de

Prestel books are available worldwide. Please contact your nearest bookseller or one of
the above addresses for information concerning your local distributor.